COLOR LIGHT & COMPOSITION

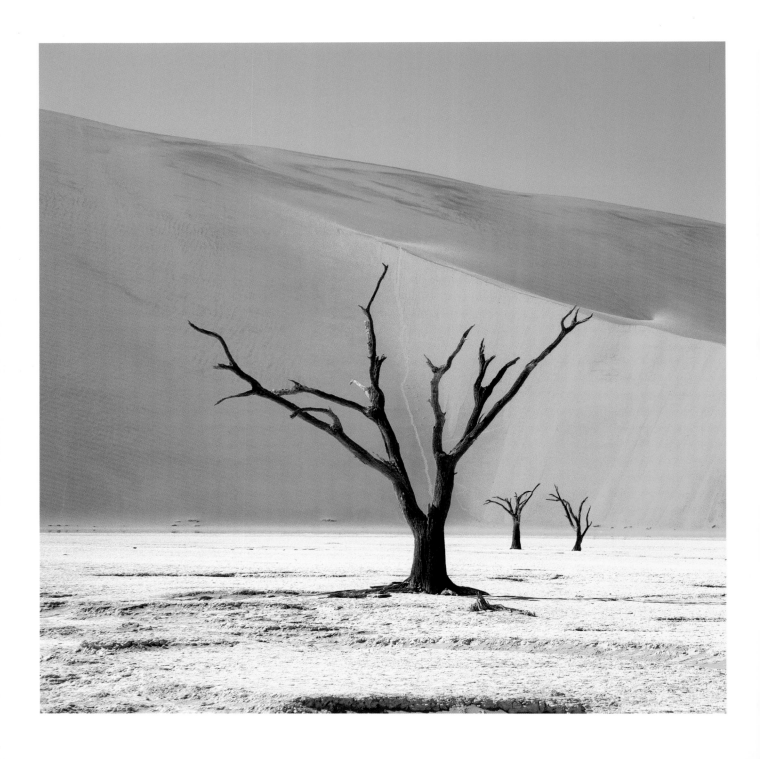

SUE BISHOP

COLOR LIGHT & COMPOSITION

A PHOTOGRAPHER'S GUIDE

First published 2010 by
Photographers' Institute Press
An imprint of
Guild of Master Craftsman Publications Ltd
Castle Place, 166 High Street,
Lewes, East Sussex BN7 1XU

Text and photographs © Sue Bishop, 2010
© in the Work Photographers' Institute Press, 2010

Images on page 17 © R. Beau Lotto of www.lottolab.org

ISBN 978-1-86108-663-1

Associate Publisher: Jonathan Bailey
Production Manager: Jim Bulley
Managing Editor: Gerrie Purcell
Senior Project Editor: Dominique Page
Editor: Tom Mugridge
Managing Art Editor: Gilda Pacitti
Designer: Simon Goggin

Set in Interstate

Color origination by GMC Reprographics
Printed and bound in China by Everbest Printing Co. Ltd.

INTRODUCTION 8

COLOR

LIGHT

COMPOSITION

CONTENTS

Introduction

A camera may be simply a tool for making a basic photographic record of a subject, or it may be used in a more creative way to produce a more artistic image. In both cases a knowledge of the fundamental techniques of photography is required; but if an aesthetically pleasing result is desired, the photographer also needs to have an awareness of various pictorial principles, just as artists in other visual media do. Perhaps the three most important areas to understand are color theory—how colors behave and interact with one another; light, and how different types of light will affect an image; and composition—how to achieve a satisfying visual balance in a picture.

Finding a beautiful subject for a photograph is only half the battle. The challenge then consists in making a picture of that subject that goes beyond a mere record and becomes a piece of art—an image with its own validity beyond the simply descriptive. This will inevitably involve the "eye" of the photographer; in other words, the ability to see and extract a picture from the elements in the scene in front of him. The question "what is art?" has been debated by many thinkers over the centuries and is beyond the remit of this book; but for our purposes it is enough to say that an artistic photograph is one in which technical knowledge has been combined with the vision of the photographer to create an image of beauty—something that will not only inform its viewers but also inspire them.

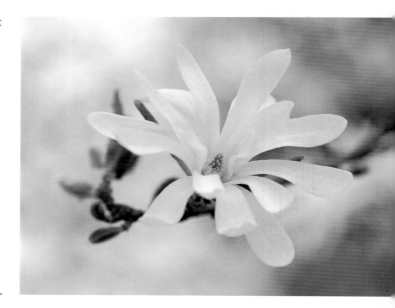

"Everything has its beauty but not everyone sees it."
Confucius

"Anything under the sun is beautiful if you have the vision—it is the seeing of the thing that makes it so."
Charles Hawthorne

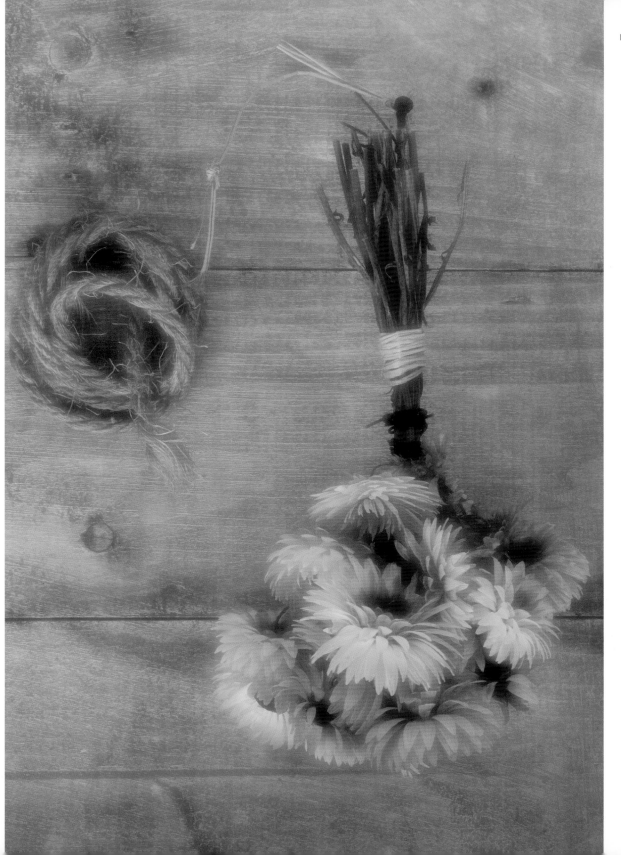

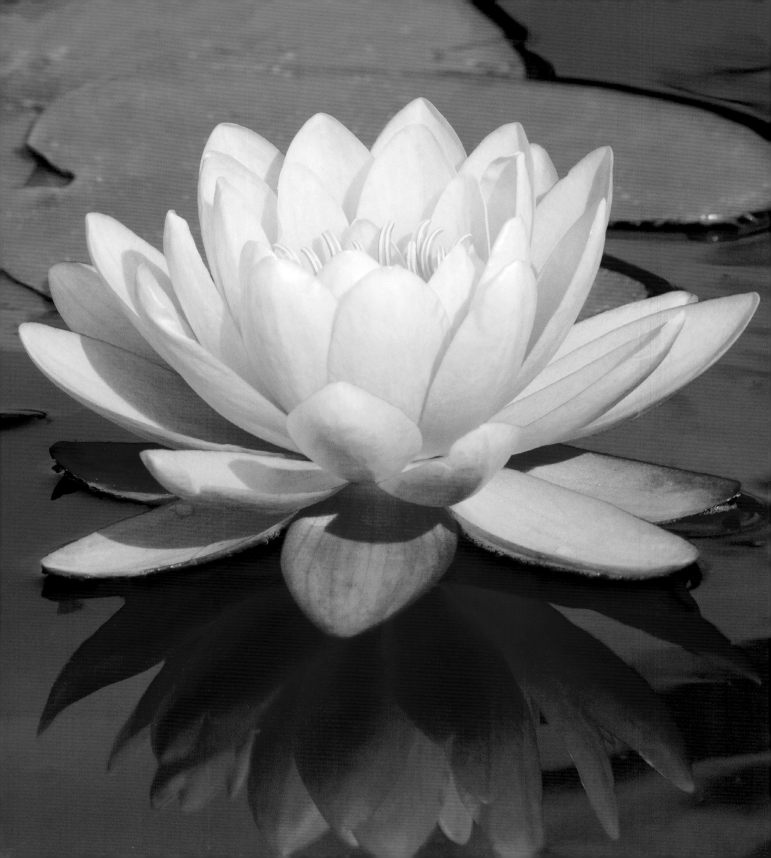

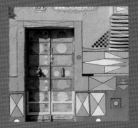

COLOR

The properties of color

The spectrum of colors in the world around us is seemingly infinite. To say that something is blue barely begins to define it—there are so many different shades and hues of blue, and each particular hue can be either saturated or pastel; our perception of these shades is then further affected by the kind of light that falls on them. This dazzlingly boundless variety of colors provides the artist's palette from which the photographer makes an image.

Most of us would say that we are able to describe any color we see with a fair degree of accuracy. However, we seldom see one color in isolation, and our perception of a color will usually be affected by the colors around it and by the relative brightness of the different colors in the scene. One might imagine that a particular shade of red or blue will always look the same, irrespective of the context, but in fact this is far from being the case.

THE EFFECT OF COLORS ON EACH OTHER

To make the most effective use of color in a photograph it is important for the photographer to understand the way in which different colors affect each other. The relationship between colors is often represented by a color wheel, in which the three primary colors—red, blue, and yellow—lie at three points of the circle, and between them are the secondary colors—purple, green, and orange—produced by mixing each pair of primaries. This is a simplified version; a full color circle would show all the various shades produced as each color merges into the next. Colors that are adjacent to each other on the wheel harmonize together—for instance, blue and green are harmonious colors. Colors that are on opposite sides of the color wheel contrast with each other, and the maximum contrast will occur between a color and the one directly opposite it—red and green, for example. These pairs of colors are known as complementary colors and will give the greatest impact if used together in a photograph.

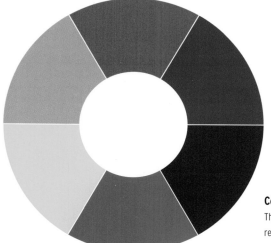

Color wheel
The color wheel is a diagrammatic representation of the relationships between different colors.

Moroccan shoes
The souks of Marrakesh offer plenty of opportunities for colorful photographs. Although there were many different hues within this image, I felt they worked well together, especially since they were united by the repeated pattern of the shoes.
Panasonic DMC-LX2, lens at 6.7mm, ISO 400, f/2.8 at 1/30 sec

In addition, the color wheel has a "warm" side and a "cool" side—the reds, oranges, and yellows are warm colors while the blues, greens, and mauves are cool. In practice, warm colors are dominant in an image and draw the eye while cool colors recede and do not clamor for the viewer's attention. It's very important to bear this in mind when composing a photograph, as a dominant color will demand attention from the viewer whether or not it was intended to be the main subject of the photograph.

Red tulip
The reds and yellows of this tulip are warm, dominant colors, and they leap vibrantly forward from the cool, receding colors of the background.
Nikon D2x, 105mm macro lens, ISO 100, f/3.8 at 1/400 sec

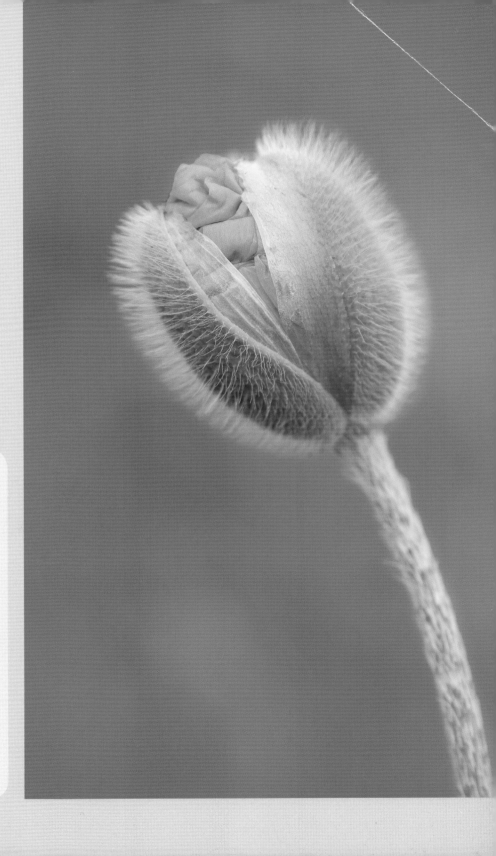

Poppy bud
I loved the way that the petals emerging from this poppy bud looked like crumpled silk. To show the red petals to their best advantage I positioned myself so that the poppy was against a plain green backdrop, which I threw out of focus by using a wide aperture.
Nikon D2x, 105mm macro lens, ISO 100, f/5 at 1/180 sec

VISUAL BALANCE

The relationship between dominant and receding colors should be considered when using complementary colors to provide contrast and impact in a photograph. For instance, if you wanted to photograph an orange vase you might position it against a blue background (blue being the complementary color to orange) in order to make the best use of color contrast; but an image of a blue vase against an orange background, while still providing the same color contrast, would feel uncomfortable, because the subject would be a receding color while the background was a dominant color.

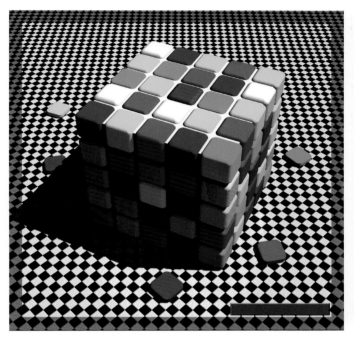

Optical illusion

Our perception of a color is affected by the relative brightness of it and other colors surrounding it. To try this optical illusion follow the instructions provided on the right.

Allium

I photographed this delicate allium flower in front of other flowers of the same type, so that the foreground and background would both consist of soft blues, mauves, and greens. These colors are from the cool side of the color wheel, and they all harmonize with each other. This produces a much gentler image than the photo of the red tulip (see page 14), which uses complementary, contrasting colors.

Nikon D2x, 105mm macro lens, ISO 100, f/3.5 at 1/200 sec

RELATIVE BRIGHTNESS

We have seen that our perception of a color is affected by the other colors around it. Another factor that affects our perception is the relative brightness of that color and those around it. Shown above is an optical illusion created by R. Beau Lotto that clearly illustrates this phenomenon. Look at the center square on the top face of the cube and the center square on the front face, and ask yourself what color each square is. You would probably agree that the top square appears to be a shade of brown, while the front square seems to be orange. In fact, both squares are exactly the same color—you can prove this to yourself by covering up the rest of the picture so that only those two squares can be seen. But even when you know this to be true, it is impossible to see it when looking at the squares in the context of the whole cube.

Warm and cool colors

Much has been written about the psychological and emotional effects of colors and the various associations we make with them. Many color associations are culture-related—for instance, different cultures associate different colors with marriage or with death. Other associations are more universal, such as reds and oranges being associated with fire, greens with the natural world, and blues with the sky or water. The same color can have both positive and negative connotations—for example, red is said to represent warmth and energy (positive) but also aggression (negative).

WARM COLORS

Reds, oranges, and yellows are dominant, powerful colors in an image and will grab the viewer's attention. In terms of their effect upon the viewer's emotions, they are said to be happy, positive, uplifting, and energizing. Sometimes a small amount of a dominant color is all that is needed in a photograph—too much of one strong color, or too many different dominant colors together, can be visually overwhelming.

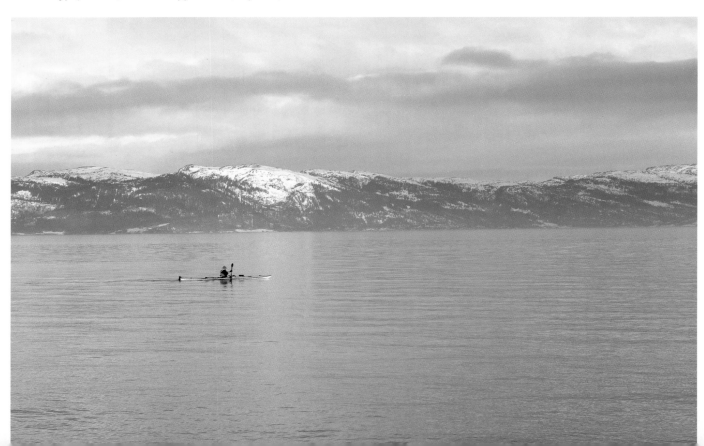

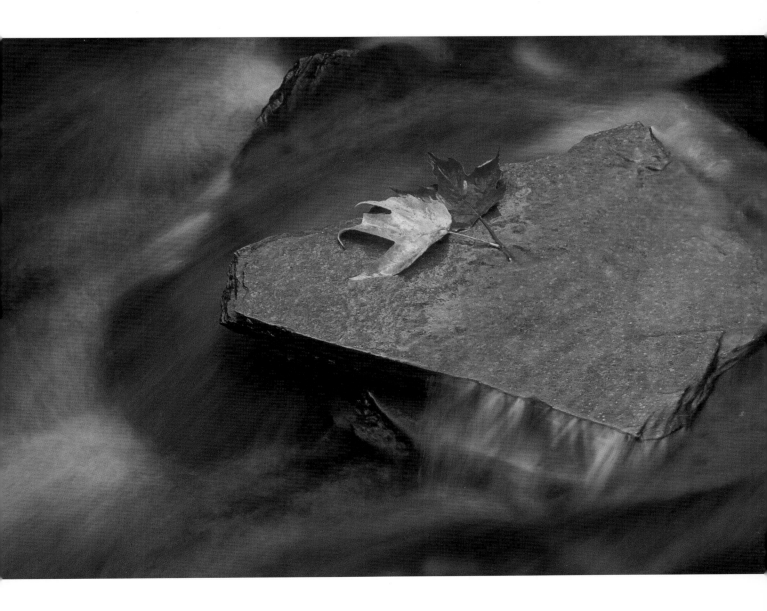

Lone kayak, Norway (left)
This kayak is tiny in the cold, gray-blue expanse of the water and sky, but because of its warm, dominant color there is no doubt that it is the focal point of the photograph.
Nikon D2x, 28–70mm lens at 70mm, ISO 100, f/8 at 1/160 sec

Leaves in stream
The two red and yellow leaves occupy a relatively small area in this photograph, which otherwise consists largely of neutral grays, but because they are strong, dominant colors they immediately attract the eye and demand the viewer's attention.
Nikon F3, 55mm macro lens, Fuji Velvia 50

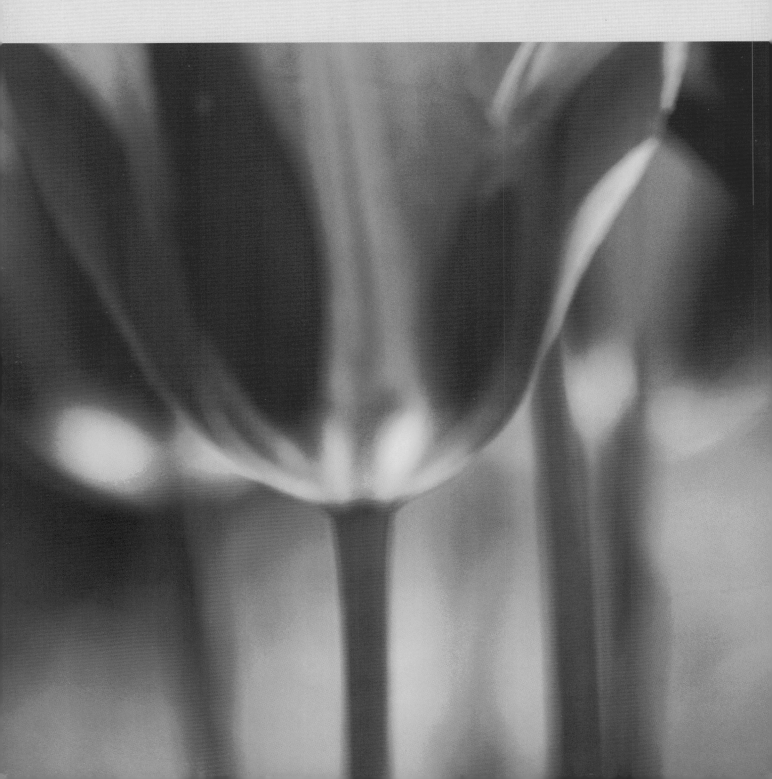

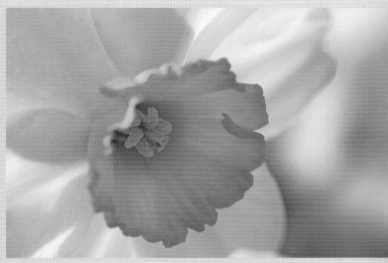

Narcissus

The yellows and oranges of the center of this narcissus are warm colors, and together with the white of the outer petals they provide an image with a feeling of freshness and sunshine.

Nikon D2x, 105mm macro lens, ISO 100, f/6.3 at 1/750 sec

Tulip impression

The lovely warm reds and yellows of these tulips were enhanced by backlighting and supported by the oranges and pinks behind them. I threw the flowers out of focus to increase the warm glow of the petals.

Nikon F100, 55mm macro lens, Fuji Velvia 50

COOL COLORS

The cool side of the color wheel consists of the greens, blues, and mauves. These colors are receding—that is, they seem to move away from the viewer, as opposed to the dominant colors that advance toward the viewer. Their emotional effect is said to be calming, serene, and restful. If you were choosing a color scheme for a relaxation room in a spa, you would certainly choose these cool colors rather than reds and oranges, which are far from restful. Different shades of blue and green often harmonize beautifully, providing lovely gentle images.

COLOR CONNOTATIONS

Each color can have both positive and negative connotations. This is particularly true of blue, which on the one hand is serene and calming, but on the other can be perceived as cold and unfriendly. In surveys, however, it seems that blue regularly appears as the top-scoring favorite color.

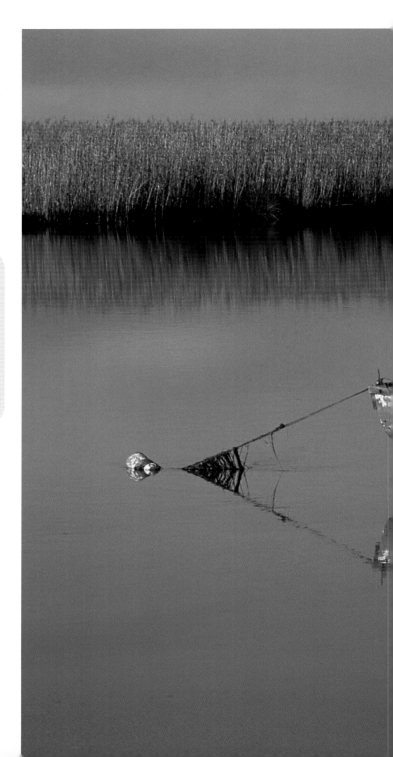

Blue boat, South Africa
I had gone to a little river in South Africa before dawn, hoping for some pictures, but when I arrived everything was covered in mist. Then the sun rose, burning off the mist, and this wonderful scene appeared before me. I find it a very serene image, and there are several reasons for this: first, blue is a calm and relaxing color; second, there are only really two colors in the image, blue and brown, which makes it visually restful; and third, the mirror-like reflection in the unruffled water adds to the feeling of tranquillity.
Nikon F3, 28-105mm lens, Fuji Velvia 50

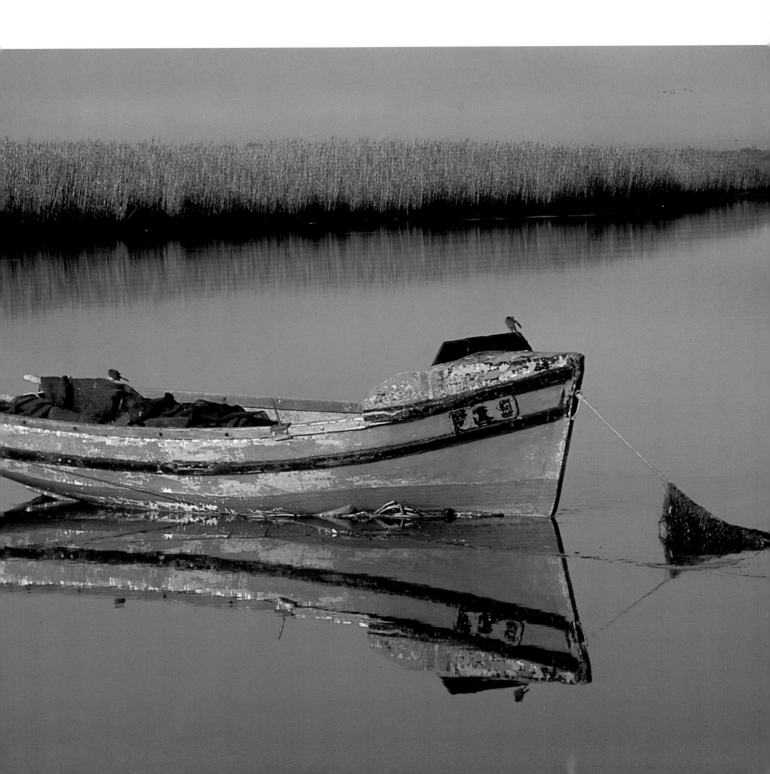

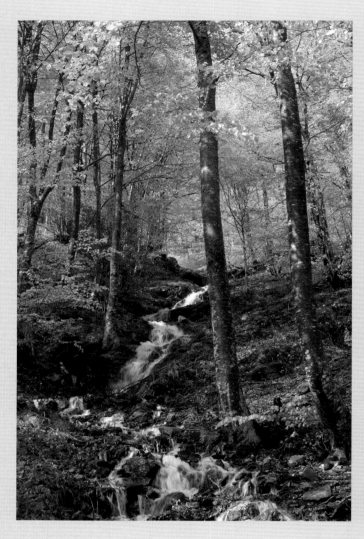

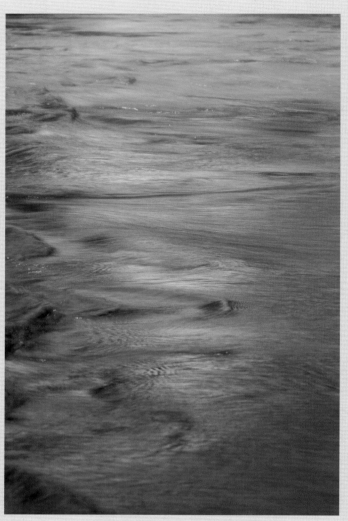

Stream and trees
Green is a very restful color and is, of course, strongly associated
with nature. Lush greens in a landscape indicate the presence
of plenty of water, and this has positive associations at a
subconscious level. Freshly emerged leaves, like those in
this photograph, are a light, yellowy green, giving a feeling
of freshness, new life, and hope.
Nikon D1x, 28-105mm lens at 38mm, ISO 125, f/16 at 1/20 sec

Blue and green reflections
All the different shades of blue, turquoise, and green seen
in this river harmonized beautifully, producing a serene and
gentle abstract image.
Nikon F3, 28-105mm lens, Fuji Velvia 50

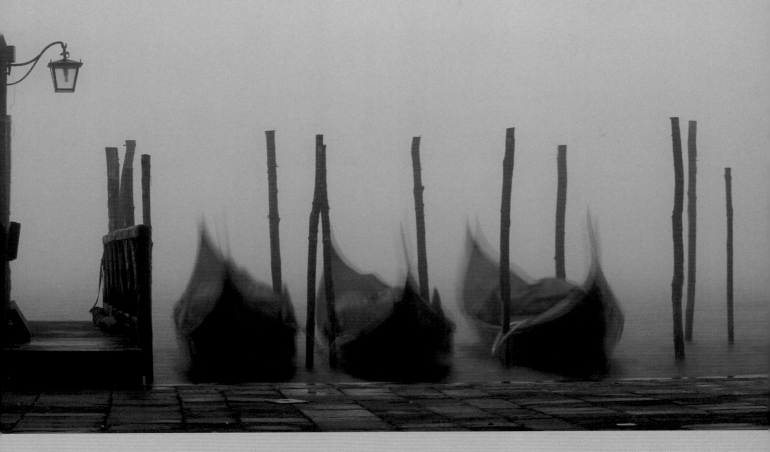

Gondolas in fog, Venice

I photographed these gondolas on a foggy morning, and
the cold light caused a blue color cast in the resulting image.
I put the camera on a tripod and used a long shutter speed so
that the water would be blurred and the rocking movement
of the gondolas would result in some movement blur. In this
instance, the blue cast has given a cold feel to the photograph
rather than a serene one.

Nikon F100, 28–105mm lens, Fuji Velvia 50

Dominant and receding colors in the background

As we've seen, warm colors in an image advance toward the viewer while cooler colors recede. It's important to bear this in mind when considering which colors are in the background of your image. If the subject of your picture is a cool color, any warm, dominant color behind it, even if it is only a small area, will pull the eye away from the subject. If your subject is a dominant color, cool colors in the background will not generally be a problem.

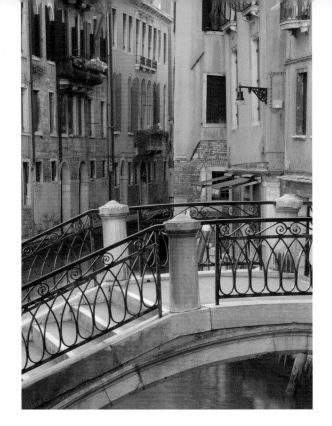

Bridge, Venice

Although there are many warm tones in this photograph, they are mostly muted pastel colors. The saturated red of the wooden posts is much more dominant than any of the other colors and distracts the viewer's attention from the more pleasing parts of the image (top). In the second picture (bottom), I have desaturated the red of the posts in Photoshop, and you can see how the photograph works better when the eye is no longer being drawn by the dominant red.
Nikon D2x, 18-200mm lens at 75mm, ISO 100, f/22 at 1/2.5 sec

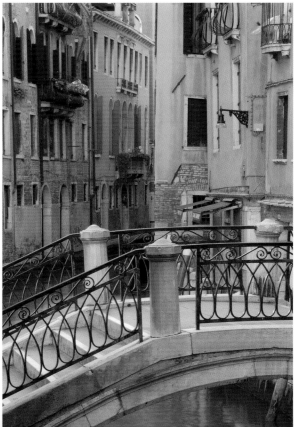

Water lily (far right)

When photographing flowers there is often a natural and pleasing balance between warm and cool colors because the foliage is usually green and therefore provides an undistracting, receding background to a flower. A problem will only arise if there is another warm or brightly colored flower in the background behind your main subject. In this photograph, the warm pink of the water lily is set off beautifully by the non-competing greens and blues of its background.
Nikon D2x, 80-400mm lens at 270mm, ISO 100, f/16 at 1/40

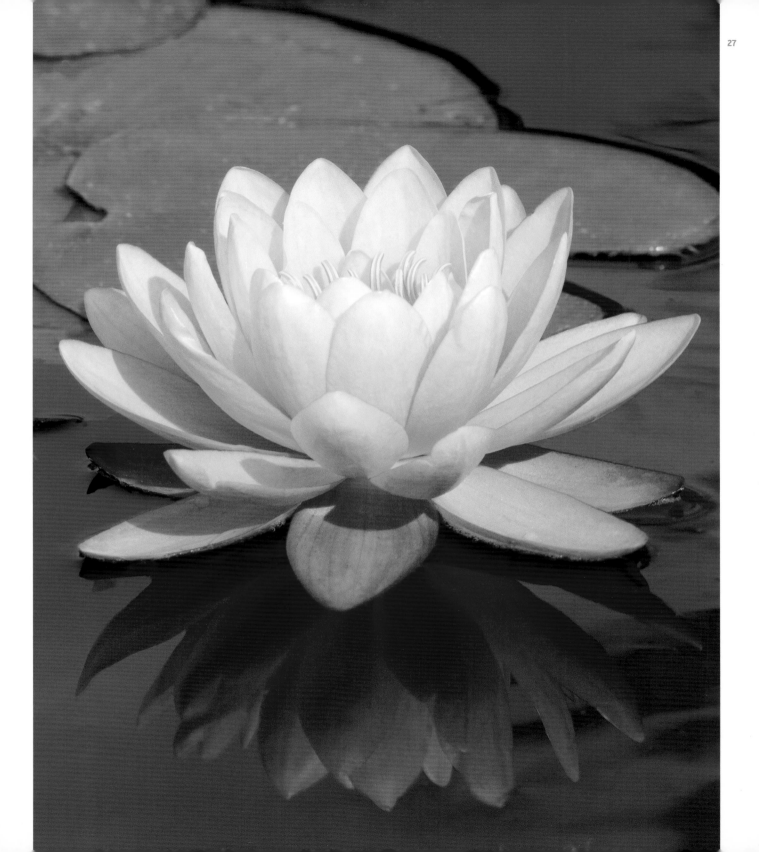

Using saturated colors

A saturated color is defined as a pure hue that is not diluted by white. However, we often use the term more widely to describe any color that is rich and strong—thus we can talk about a saturated pink, even though pink is technically a dilution of red with white.

Any hue will have a greater visual impact in its saturated form than in a diluted form. Combining the three primary colors in a saturated form will produce a visually powerful image but never a subtle one, and the contrasting effect of complementary colors is at its strongest when the colors are fully saturated. Saturated colors are usually at their most vibrant in bright light, and can often be further enhanced by the use of a polarizing filter (see page 47).

Prayer flags, Bhutan
In Bhutan, as in other Buddhist countries, prayer flags can be found everywhere, constantly fluttering in the breeze. The vivid colors of these flags looked particularly bright against the intense blue backdrop of the sky. I put the camera on a tripod and used a long enough shutter speed to blur their movement; I didn't want a static picture because the motion is part of the essence of the prayer flags. I used a polarizing filter to saturate the colors even more.
Nikon F100, 200mm lens, Fuji Velvia 50

Fall foliage, Vermont, USA

The already vibrant shades of these
red and orange fall trees are seen
at their most saturated in the strong,
direct sunlight. Together with the
saturated greens of the fir trees and
blue of the sky, they make for a picture
with impact rather than subtlety.
Compare this with the picture below
right, which is also of fall trees but taken
in misty conditions—the orange hues
appear much more pastel in the soft
light, resulting in a gentler image.

Hasselblad 500C, 250mm lens,
Fuji Velvia 50 (top)
Nikon F3, 28–105mm lens,
Fuji Velvia 50 (bottom)

Using pastel colors

When a fully saturated color is diluted by white it becomes a pastel color. Pastel hues are softer and less vibrant, and when used in a photograph will result in an image with less impact and more delicacy than one with fully saturated colors. Even fully saturated colors may appear less vivid if photographed on a day with soft, overcast light. While saturated colors are at their strongest in full sunlight,

pastel colors may often benefit from a more diffused light, as harsh light can sometimes bleach out their more delicate and subtle tones. The same color relationships between harmonious or complementary colors, and between dominant and receding colors, apply when using a pastel color palette, but the effect of color contrast will never be as strong as it is with saturated hues.

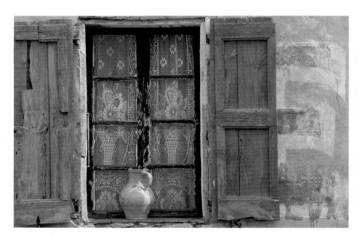

Window with jug, Provence
I loved the faded, muted shades of the green shutters and yellow wall of this house, and the presence of the jug, whose color toned so well with the wall, seemed to tie it all together. When I arrived, the entire window and wall were in shade, but after ten minutes or so the sun crept around the edge of the building just enough to touch the side of the jug with a slick of light, which was a wonderful bonus. The lack of direct sunlight was ideal for enhancing the pastel colors; a short while later the sun came farther round and hit the window and the picture was lost—the contrasty light caused patches of light and shadow on the shutters and wall, and reflected off the window glass so that the lace curtains could no longer be seen properly.
Nikon F3, 200mm lens, Fuji Velvia 50

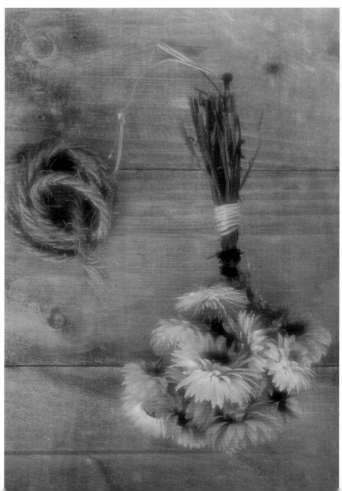

Dried flowers (below left)

This bunch of dried flowers was hanging in a potting shed whose walls had been painted a wonderful shade of cornflower blue. The delicate colors of the petals were set off beautifully by the faded blue of the wood behind them, allowing me to take a photograph consisting entirely of gentle, pastel shades. I added a little soft focus in Photoshop to add a dreamy quality to the image.

Nikon D2x, 105mm macro lens, ISO 100, 25 at 1.3 sec

Allium

Care needs to be taken when photographing pastel-colored subjects in bright light, as delicate pastel hues can easily appear washed out in full sunlight. I liked the sparkling effect of the sun on the out-of-focus flowers in the background of this picture, but didn't want too much sun on the subject flowers themselves. The light filtering through other foliage onto the flowers was patchy enough for me to just about get away with it, but you can see that where the sun is shining fully on the petals the subtle colors appear a little bleached out.

Nikon D2x, 105mm macro lens, ISO 100, f/3 at 1/350 sec

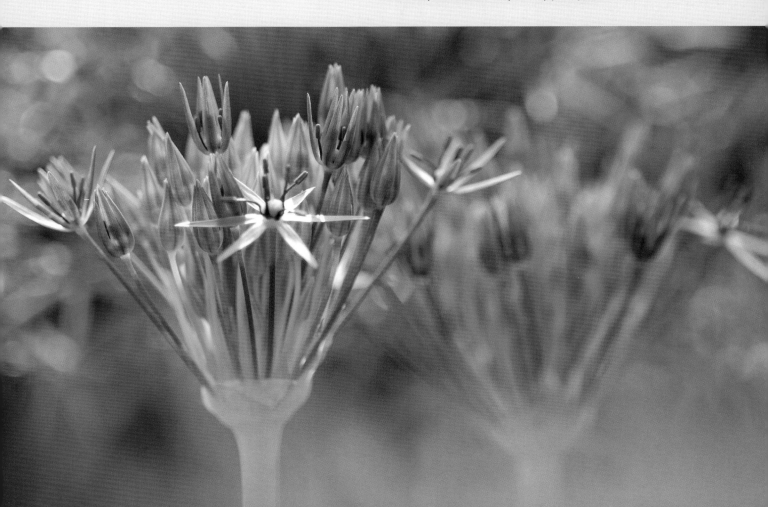

Using a large or limited color palette

When composing a photograph, we select the elements from the scene in front of us that we want to include in our image, and one of the key considerations will be the colors of those elements. We have already seen how the balance of dominant and receding colors, or the use of harmonizing or contrasting colors, will affect the resulting photograph, and in addition we need to consider how many different colors to include. A photograph with a riot of different colors will have a very different effect from one that uses just two or three hues. Using many colors can create a visually exciting and dynamic image, but if care is not taken it can also cause visual confusion so that the viewer's attention is pulled in all directions, and he is not quite sure which part of the picture he should focus on. Using just two or three carefully chosen shades, whether contrasting or harmonizing, can sometimes result in a visually more sophisticated image and perhaps a more restful one—look again at the photo of the blue boat on page 23.

The question of whether the colors are saturated or pastel will also have a bearing on the final result. An image using many different pastel shades is less likely to be visually overwhelming than one using many saturated colors.

None of this is to say that you should never use a large color palette—it can result in a wonderful image, so long as you are aware of the effect that all the colors are having in your photograph.

Acer
The combination of a limited color palette and the use of the color green, which is a cool, receding color, has produced a quiet, restful image. Compare the way your eye rests in this photograph with the way it darts about in the image of the Burano house on page 34.
Nikon D2x, 105mm macro lens, ISO 100, f/13 at 1/20 sec

Pink rhododendron
This photograph uses a very limited color palette—it is almost entirely pink with just small touches of green. To isolate the subject flower from others of the same color behind it, I used a wide aperture and focused on the front flowers, throwing the background ones out of focus. In flower photography, using a backdrop of the same kind of flowers and throwing them out of focus is one way to be sure of having a harmonious backdrop.
Nikon D2x, 105mm macro lens, ISO 100, f/7.1 at 1/100 sec

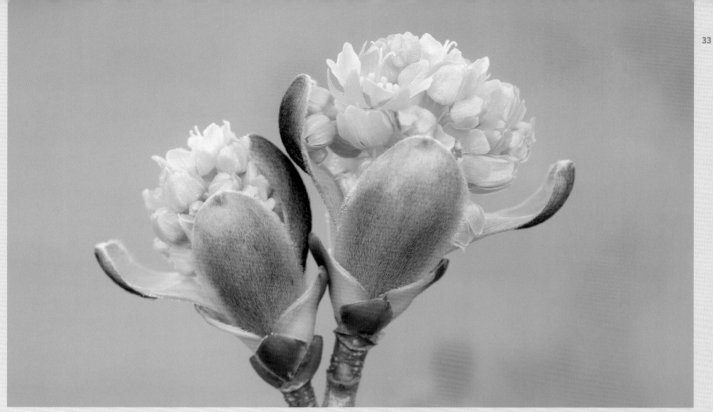

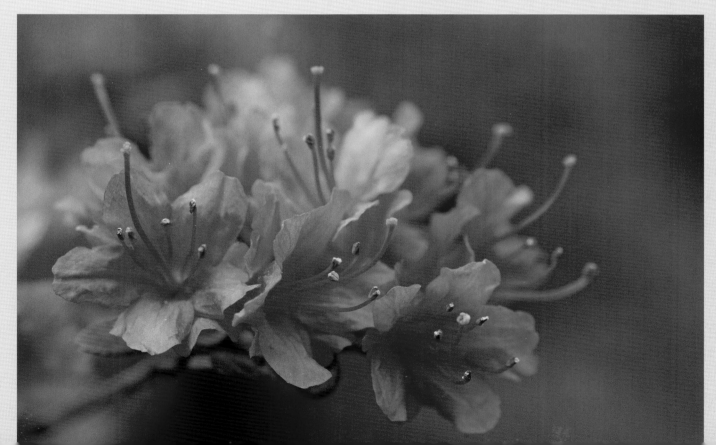

Multicolored house, Burano, Italy (left)

It would be impossible to take a subtle photograph of this crazily painted house—it is a large color palette in itself! The saturated colors are vivid in the sunlight and make for an image with impact. Notice how your eye tends to wander all over the photograph rather than finding one focal point to rest on.

Nikon D2x, 28–70mm lens at 28mm, ISO 100, f/14 at 1/40 sec

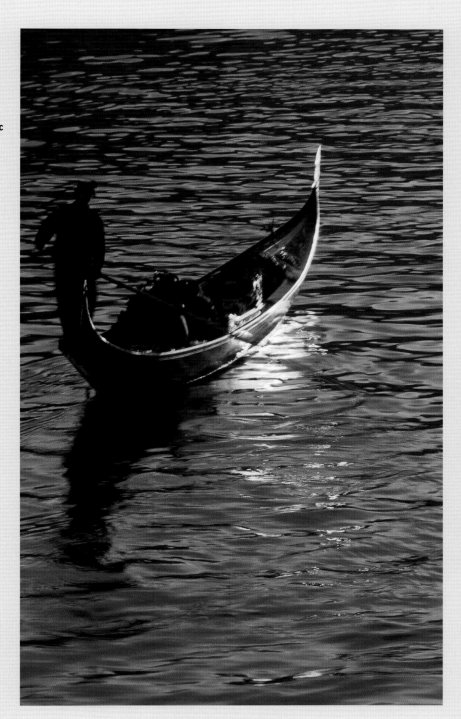

Gondola at sunset, Venice

I went to the Rialto Bridge toward the end of the day to try to photograph the gondolas as they rounded a particular bend in the canal and came into a position where the setting sun just caught them. It was intensely frustrating, as almost every time a gondola arrived in the correct position a vaporetto would arrive too and get in the way! Eventually I did get one perfect moment to take the photograph. Shooting against the light has resulted in a photograph with a limited color palette of gold and black.

Nikon F100, 200mm lens, Fuji Velvia 50

Color as the subject of the photograph

Usually when I find something I want to photograph I'm attracted by a combination of its color and its form, and often by the quality of the light. Sometimes, however, I find that it is just the color in a scene or an object that attracts me rather than its shape or form. In these cases I will often make an image that is all about the color, and frequently the emphasis on color, to the exclusion of other qualities in the subject, will result in a fairly abstract image. This can be achieved by careful composition to include the colors in question and exclude all others, often by cropping in close and photographing just part of the scene or subject.

REFLECTED COLORS
When photographing reflections, it is useful to bear in mind that the reflected colors will be strongest when the reflected object is in sunlight but the water is in shade.

Venice reflection
I loved the colors of a particular little scene in Venice, but a straight photograph seemed to provide too much literal information that interfered with my enjoyment of the warm pastel hues. So, instead of photographing the building itself, I photographed its reflection in the canal below. This resulted in a much more abstract image in which the colors can be appreciated and the shape and form are suggested rather than fully defined.
Nikon F100, 28-105mm lens, Fuji Velvia 50

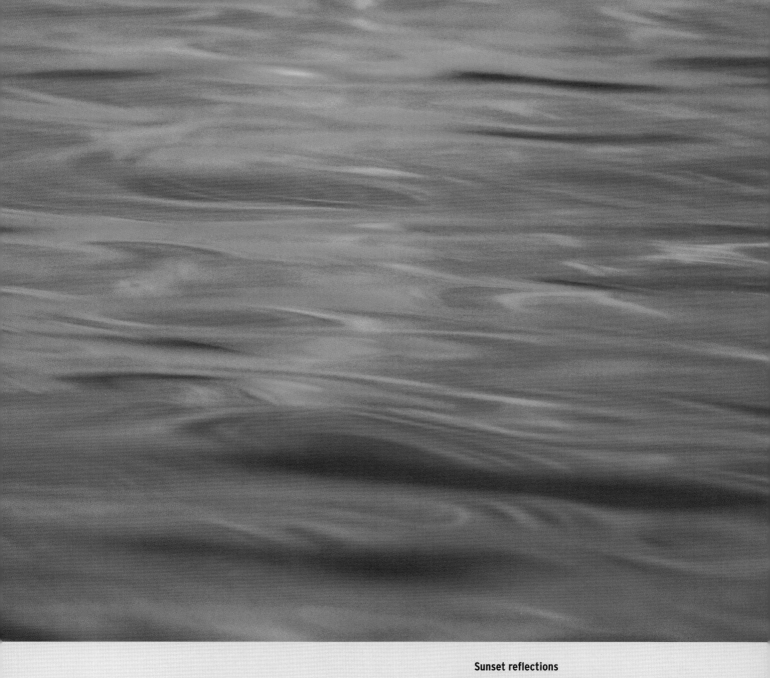

Sunset reflections
The gorgeous orange reflections of the setting sun contrasted
beautifully with the soft blues of the water, so I used a telephoto
lens to fill the frame with color, using a shutter speed slow
enough to allow a little movement in the water.
Nikon F100, 28-105mm lens, Fuji Velvia 50

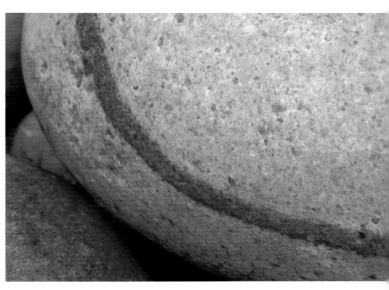

Pebbles

I was attracted by the unusual colored ring around this pebble, but a photograph of the whole stone included too much gray and was uninteresting. I placed the pebble next to another whose warm color echoed the ring in my first one and cropped in close, framing only a small part of each pebble to emphasize the color relationship between them.

Nikon F3, 55mm macro lens, Fuji Velvia 50

Golden avenue

This avenue of fall trees had some beautiful colors, but there were also a few bare branches and areas where the color was less interesting. I decided to make a panned photograph, which has resulted in an abstract, impressionistic image and emphasized the glorious warm hues by spreading them across the frame of the photograph. For more information about panning, see page 150.

Nikon D1x, 105mm macro lens, ISO 125, f/13 at 1/10 sec

Reflected color

It is, of course, quite common to find color reflected in water, but occasionally you can find reflected color in other places, and it can be fun to photograph it. In these two photographs a large part of the color element is reflected from an object outside the frame of the image.

Blue house with shutters, Venice
The shutters of this house were painted with a glossy black paint. At this particular time of day, the blue house was in shade, while a red house at a 90-degree angle to it was in sunlight. The black shutters have picked up a remarkably intense reflection from the red wall.
Nikon D2x, 18-200mm lens at 130mm, ISO 100, f/22 at 1/10 sec (right)
Nikon D2x, 18-200mm lens at 40mm, ISO 100, f/22 at 1/30 sec (below)

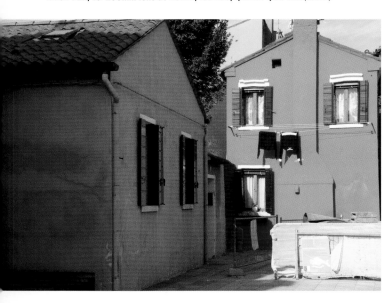

Golden wall, Venice

The facing wall of this house (on the left side of the picture) was painted yellów, but the other wall was unpainted concrete. Because of the angle of the light, the concrete wall was colored with a golden glow as light reflected off another yellow wall out of the frame. I decided to crop tightly and make a fairly abstract image consisting of shapes and angles, with a very limited color palette.

Nikon F100, 28–105mm lens, Fuji Velvia 50

Enhancing color with filters

Filters were developed in the days of film photography, and some—warm-up filters, for example—are now largely redundant for digital photographers because similar results can be achieved either via the camera's white balance settings or later on in post-processing software such as Photoshop (both of which methods will be discussed later in this book). Nevertheless, the principles of warming up a photograph apply to both film and digital, so the points made here are relevant to both.

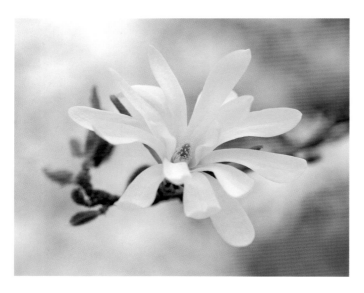

Magnolia stellata
This image of a white magnolia may not appear to have been warmed up, but in fact I added a tweak of warmth in Photoshop to compensate for the slightly cold cast caused by photographing on an overcast day.
Nikon D2x, 105mm macro lens, ISO 100, f/5 at 1/250 sec

WARM-UP FILTERS

The color temperature of natural daylight varies at different times of the day and in different weather conditions (see page 80), and this will have an effect on the color of a photograph. Under most circumstances a cold, blue color cast is felt to be undesirable in an image, unless this is the mood the photographer is intending to convey—in general, people respond more positively to pictures with a warm feel rather than a cool one.

A warm-up filter can be used to counteract a cold cast. These are pale amber or straw-colored filters that are fitted onto the front of the lens and add a warming effect to the photograph. Even when the light is not particularly cold, a warm-up filter can be used to add extra warmth to the image. It can be quite a seductive technique, so beware of adding more and more warmth and ending up with an obviously artificial result!

When warming up an image, either with filters or via the white balance settings, bear in mind that the warming effect will apply to the entire image, not just to the parts of the image that you would like to warm. In many situations this will not be a problem, but in some cases it will, especially if you are including sky in your photograph. The warming effect can muddy the clarity of a blue sky and detract from its pure color. In such a situation the only way to warm the landscape without warming the sky is to selectively warm only the required parts of the image in Photoshop (see page 50).

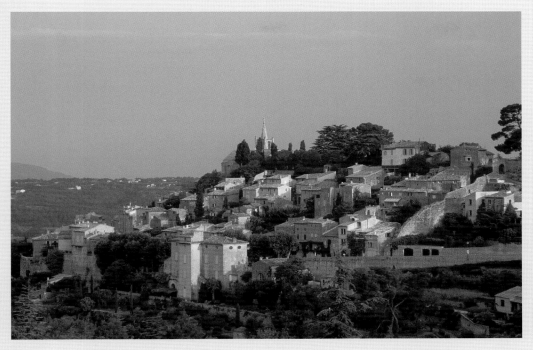

Bonnieux, Provence
Shortly after dawn the low rays of the sun began to light the old stone buildings of this lovely village (top). Although the light was warm, I decided to further enhance the golden color of the stone by using a warm-up filter. The filter succeeded in doing this, but at the same time it has muddied and detracted from the clear blue of the sky (bottom).
Nikon F3, 28–105mm lens,
Fuji Velvia 50 (top)
Nikon F3, 28–105mm lens,
Fuji Velvia 50, warm-up filter (bottom)

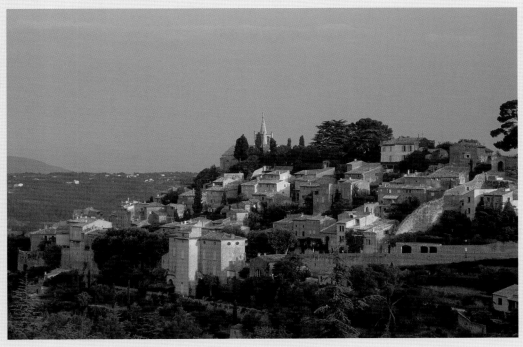

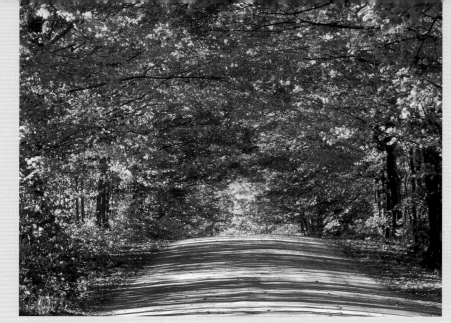

Vermont avenue, USA

The colors in this image were not as warm as I would have wished, so I decided to add a little extra warmth with a warm-up filter. I also used a soft-focus filter to spread and emphasize the golden highlights. The first photo (right) shows the unfiltered scene, and the second (below) shows the result of using the filters. Finally, I turned the camera to a vertical instead of a horizontal orientation (opposite) as I felt that it gave a better feeling of depth in the composition.

Nikon F3, 28–105mm lens, Fuji Velvia 50 (right)
Nikon F3, 28–105mm lens, Fuji Velvia 50, warm-up filter (below and far right)

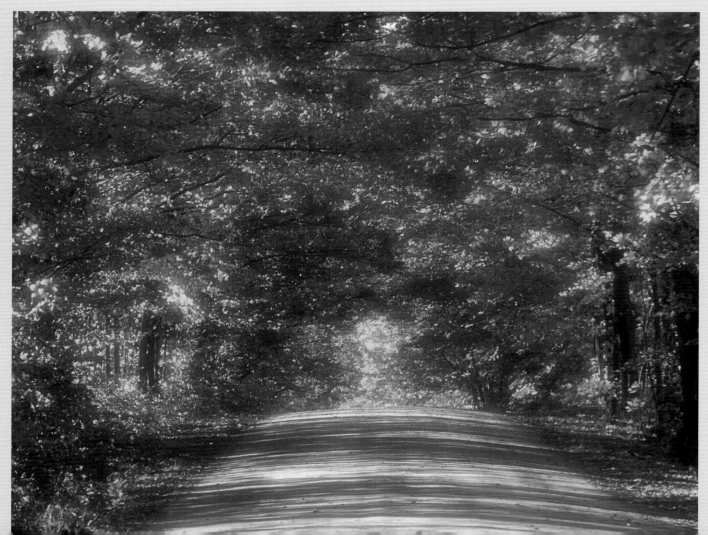

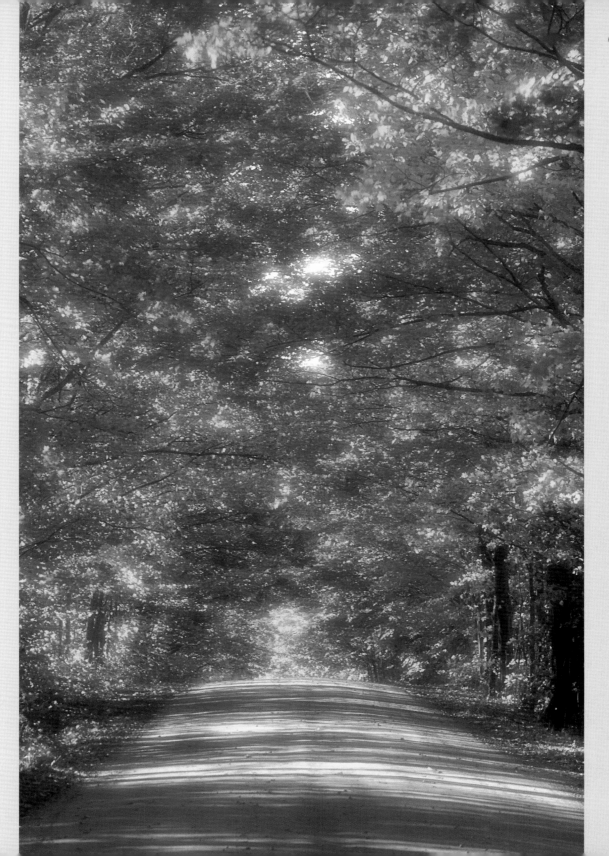

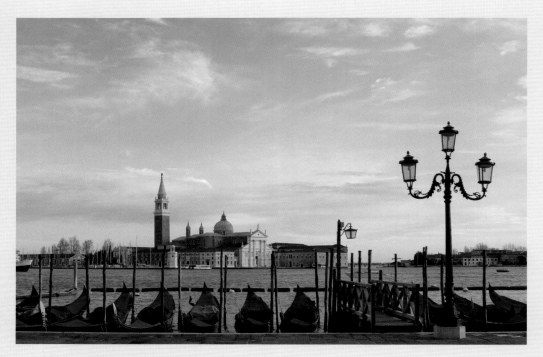

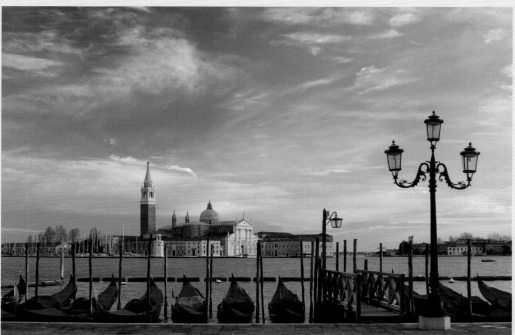

San Giorgio Maggiore, Venice
These two photographs illustrate the dramatic difference that a polarizing filter can make to a sky. The sun was coming directly from my right, the optimum angle for the polarizer to have its full effect and enhance the contrast between the rather lovely clouds and the blue sky.
Nikon D2x, 28–70mm lens at 31mm, ISO 100, f/22 at 1/20 sec (top)
Nikon D2x, 28–70mm lens at 31mm, ISO 100, f/22 at 1/5 sec, polarizer (bottom)

POLARIZING FILTERS

Polarizing filters are useful for both film and digital photographers. They are perhaps best known for deepening the color of a blue sky, but they can also reduce white light reflection from glossy objects and thus enhance and saturate their color. Polarizing filters work best when the sun is coming from the side—they will not have much effect on an object which is frontlit or backlit. The polarizing effect can be seen by turning the ring of the filter while looking through the lens. Remember that you do not always have to use the filter at its maximum effect—sometimes just a touch of polarization is all that is needed. In some locations, when the air is very clear and the sky is already an intense blue, a polarizing filter can actually darken the sky too much and look obviously artificial.

POLARIZATION AND EXPOSURE

It is worth noting that a polarizing filter is quite dark and will affect your exposure by a couple of stops. The camera's TTL meter will adjust for this automatically, but be aware, especially if you are hand-holding, that you will have a slower shutter speed when using the filter. In the photograph of San Giorgio, opposite, I wanted to use an aperture of f/22 for maximum depth of field; adding the polarizer lengthened my shutter speed from 1/20 sec to 1/5 sec. My camera was on a tripod so camera shake was not a problem, but I had to wait for a lull in the wind in order to avoid movement blur in the gondolas.

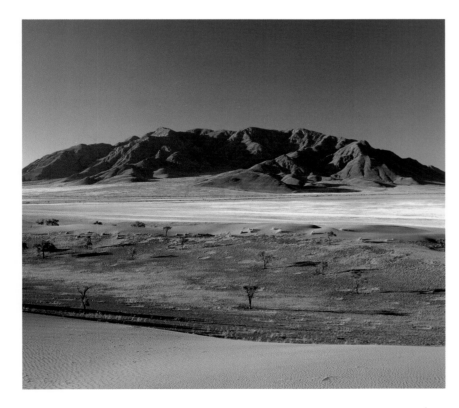

Namibian plain at sunrise

The use of a polarizer has enhanced the already strong, saturated colors in this photograph and further deepened the blue of the sky, adding to the overall impact of the image.
Hasselblad 500C, 80mm lens, Fuji Velvia 50, polarizer

Enhancing color in Photoshop

There are many different things one can do to the color of a photograph using image-editing software such as Adobe Photoshop, some of which can render the original image almost unrecognizable. The purpose of this section, however, is to look at a couple of techniques that can subtly improve the color of a photograph rather than change it radically.

The image enhancements shown in this section and in the other Photoshop sections in this book can all be achieved using most standard photo-editing software packages, notably Photoshop and Photoshop Elements (a budget-priced version of Photoshop that retains most of the functionality of the full version). The methods are described using Photoshop Elements 6 as an example, but the process is broadly similar in Photoshop and other programs. There will also be other ways to obtain similar results, but the methods described here are the ones I find most useful, and are quick and easy to apply.

COLOR SATURATION

Sometimes the color of a digital photograph will seem a little less vivid than you might have hoped, especially when shooting RAW files. It's very easy to boost the saturation in Photoshop—the only danger is the temptation of going too far and oversaturating the colors. As with many other photo manipulation techniques, less is more, and a subtle tweak that still looks natural will be more effective than an obviously artificially enhanced image.

To adjust the color saturation, click on Enhance>Adjust Color>Adjust Hue/Saturation (if you are using Photoshop Elements) or Image>Adjustments>Hue/Saturation (Photoshop). You will see a dialog box with three sliders, and it is the middle slider that you will use for this purpose. Sliding to the right increases saturation, while sliding to the left desaturates the colors. Make sure that the Preview box is ticked before you start so that you can see the effect your adjustments are having. To check how much you have changed the saturation against the original image, uncheck the Preview box and you will see the original again. These adjustments will affect all the colors in your image; if you want to saturate only one color, you can use the drop-down Edit menu and select that color from the list. When you are happy with your changes, click OK.

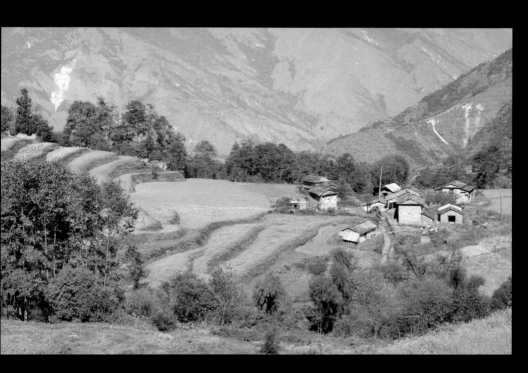

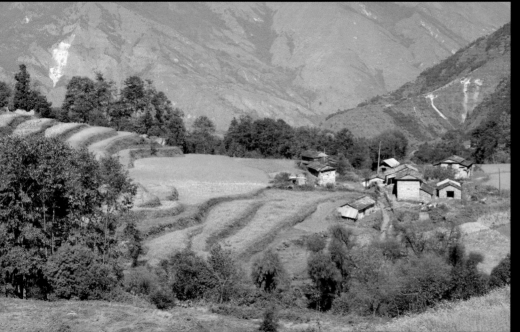

Fields with crops, Nepal
The fields of pink buckwheat and green wheat looked very vivid to my eye, but the colors were rather flat in the resulting RAW file (top). Using the color saturation tool restored the colors to their original brightness (bottom).
Nikon D2x, 18-200mm lens at 52mm, ISO 100, f/20 at 1/40 sec

ADJUSTING THE COLOR TEMPERATURE

We have seen that the colors in an image can be affected by the color temperature of the prevailing light, and we will examine this in more detail in Section 2. However, if the color temperature does produce an unwanted color cast in a photograph, it is very easy to correct in Photoshop, and there are several different ways to approach this. One of the easiest to use is the Color Variations dialog box.

SELECTIVE ADJUSTMENTS

In some cases you may wish to warm only part of the image; for instance, when you have a landscape under a blue sky—the land may benefit from a little extra warmth, but it will detract from the blue of the sky. In this situation you will need to select the area you wish to warm using one of Photoshop's various selection tools before opening the Color Variations box. When you have done this you can proceed in the same way as described here, and the color adjustments will only be applied to the selected part of the photograph.

To correct a color cast, click on Enhance>Adjust Color>Color Variations (Photoshop Elements) or Image>Adjustments>Variations (Photoshop). You will see a dialog box containing thumbnail images that show the effect of increasing or decreasing the amount of red, blue, or green in your photograph and the effect of lightening or darkening it. The amount of the increase or decrease is adjusted by using the slider. If you click on one of the thumbnails, the result of using that variation on your photograph will be shown in the After box (Current Pick in Photoshop) at the top. If you're not happy with it, you can click on Reset Image (Original in Photoshop) and try again. When you have achieved your desired result, click OK.

Hen and chicks, Nepal

It's common to see chickens roaming around the villages in Nepal, but when I saw this hen and her chicks against the harmonizing mustard color of the wall I grabbed a quick photograph. It was one of those moments where you have to take the picture quickly or it will be gone, so I didn't stop to adjust my camera's white balance to take account of the fact that I was shooting in the shade on a sunny day (see page 82). This resulted in quite a cold, blue cast to the image (top right), which I corrected (bottom right) using the Color Variations dialog box.

Nikon D2x, 18-200mm lens at 38mm, ISO 100, f/5.6 at 1/45 sec

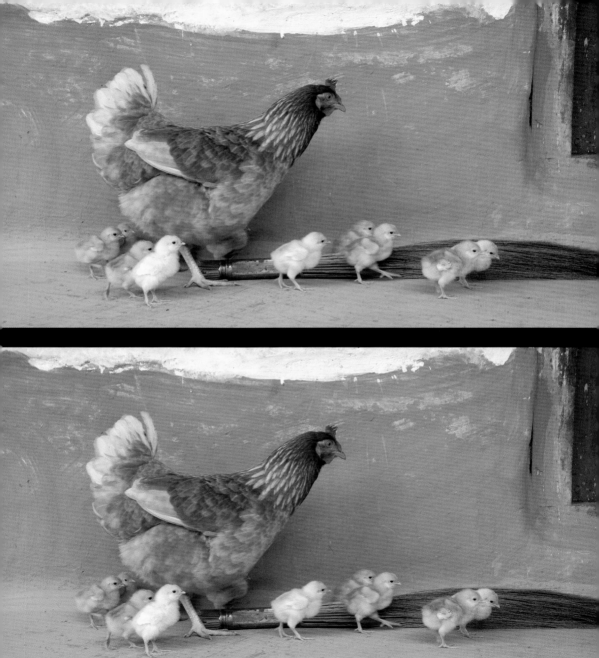

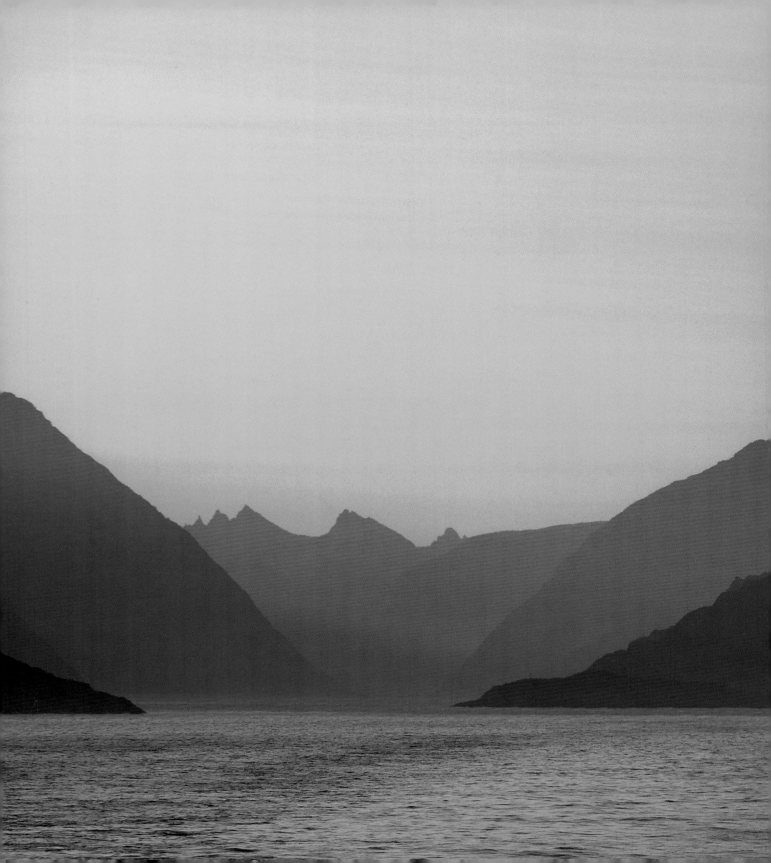

- The qualities of light • Hard light • Light that is between hard and soft • Soft light
- Front light • Side light • Back light • Changing light • Color temperature • White balance
- Enhancing lighting in Photoshop

LIGHT

The qualities of light

Light is one of the many wonderful things we take for granted, always assuming when it goes dark at night that light will appear again with the dawn of the following day. Very often we do not stop to appreciate it, much less analyze it—but as with color, light is extremely variable, and the various types of light will give very different results in our photographs. Light can be soft and diffused or hard and directional; in relation to the photographer it can come from the front, the side, or behind; its color temperature can be warm or cold. Although we may not be able to have any control over the light conditions when we are out in the field, an understanding of the properties and qualities of the different types of light makes us better prepared to make the best use of the prevailing light.

Raindrops on petals (right)
I took this photograph in my conservatory on an overcast day. In contrast to the photograph of sky and sea where the light is strong and dramatic, in this image the light is so soft and diffused that the viewer is barely aware of it as an element in the picture. This type of even, gentle lighting is particularly flattering for delicate subjects such as flowers.
Nikon D2x, 105mm macro lens, ISO 100, f/16, 1/3 sec

Sky and sea
Sometimes light can be so striking that it becomes the subject of a photograph. On the evening I took this image, the clouds began to clear toward the horizon after an overcast day, allowing the rays of the setting sun to break through dramatically over the sea.
Nikon D2x, 80-400mm lens at 135mm, ISO 100, f/6.3 at 1/125 sec

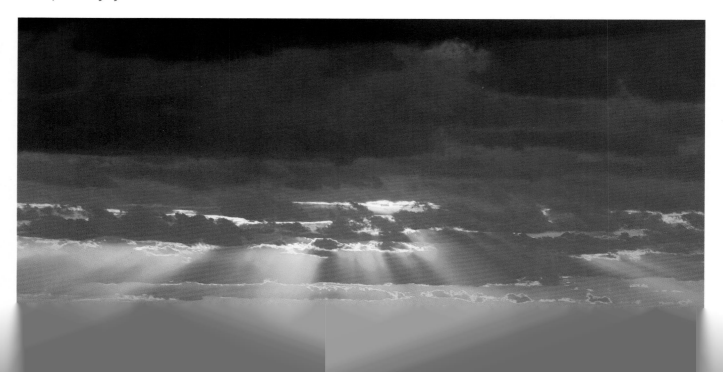

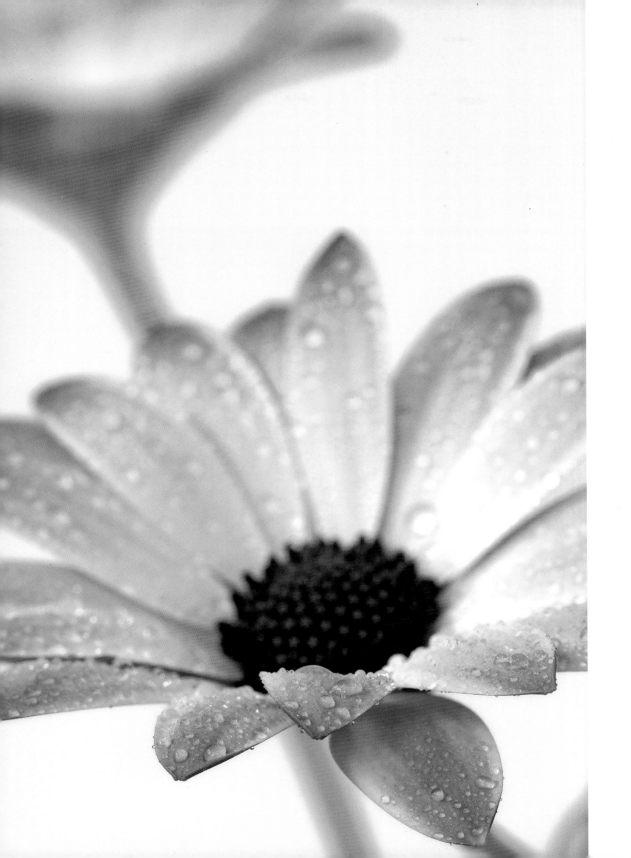

Hard light

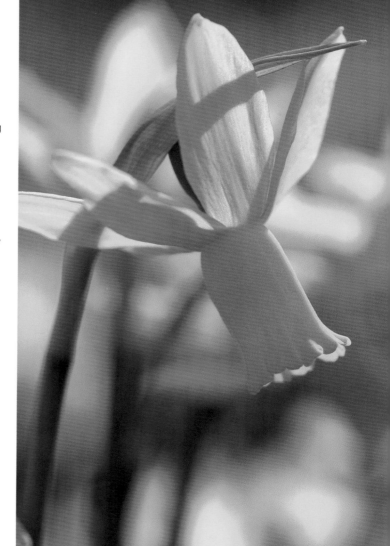

When the sun is shining from a clear blue sky its light will be hard and directional. Areas lit by the sun will be bright and vivid, while shadow areas will be dark and dense. There may be a large contrast range between these bright and dark areas, sometimes leading to burnt-out highlights or blocked up shadows if the range is too great for the camera to cope with. It's worth remembering that the human eye and brain are far better at balancing out the contrast and discerning detail in the shadows than a camera can ever be. Nevertheless, hard light can provide drama and impact in a photograph.

Hard light is also very good for defining shapes, especially when it is low and coming from the side, which can create a very three-dimensional effect in an image. In the middle of a summer's day, however, when the light is coming from directly overhead, it is generally unflattering to almost any kind of photographic subject, creating harsh contrast between light and shadow without revealing texture or form.

Daffodils
I photographed these daffodils in bright sunlight. Hard front light on flowers does not usually show them at their best, so I decided to position myself so that the daffodils were backlit and the sun shone through the petals, illuminating them with a golden glow.
Nikon D1x, 105mm macro lens, ISO 125, f/5.6 at 1/800 sec

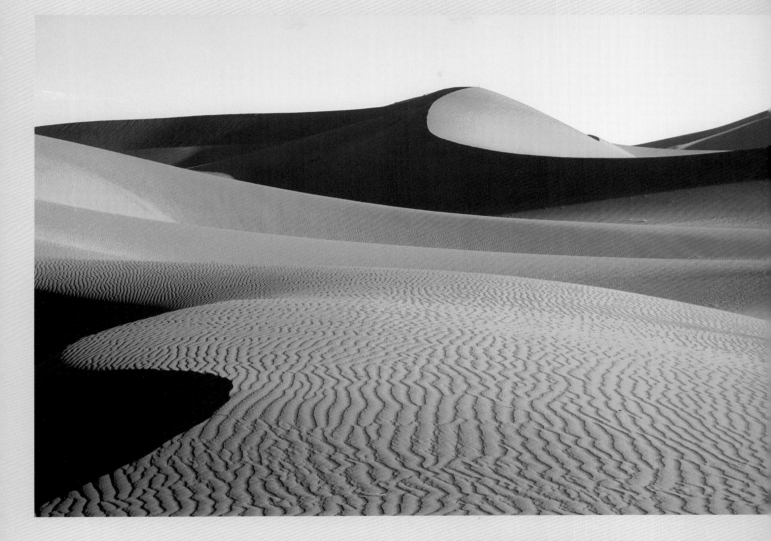

Sand dunes at Sossusvlei, Namibia

I photographed these sand dunes at dawn, and the sunlight was hard and directional. Because it was also low and coming from the side, it has added a very three-dimensional feel to the image, emphasizing not only the sweeping shape of the dunes but also the texture of all the little ripples in the sand. There is a strong contrast between the lit areas and the areas in shadow, which have become nearly black, and this has resulted in a graphic, almost abstract feel to the photograph.

Nikon F3, 28-105mm lens, Fuji Velvia 50

DEALING WITH HARD LIGHT BY USING REFLECTORS AND DIFFUSERS

While hard, directional light can be excellent for creating a photograph with impact, there are some subjects for which it is simply too harsh. This may be true of a scene in which you want to show detail in all areas rather than graphic shapes, and it is often also true of delicate subjects such as flowers. There is not much you can do to adjust the effect of hard light on a large landscape, but with a close-up subject, using a reflector or a diffuser can make a lot of difference to the resulting image.

You can buy purpose-made reflectors, which are usually either white, silver, or gold, or for smaller subjects you can equally well use a piece of white card or card covered with crumpled aluminum foil. It is easiest to have the camera on a tripod so that you have a hand free to hold the reflector and angle it so that it is reflecting some of the sunlight back into the shadowed side of your subject—in general terms, you will be holding the reflector on the opposite side of your subject to the sun. This can lighten the shadows quite significantly. A diffuser is a piece of white material stretched over a frame, which you position between the sun and your subject—the light coming through the diffuser is spread and softened so that it is no longer strong enough to cause hard shadows. While a reflector will generally lighten shadows, a diffuser will remove them completely. Remember that using a diffuser may also affect the color temperature of your photograph by, in effect, casting a certain amount of shade on your subject (see page 82).

Crocuses

I photographed these crocuses on a bright, sunny day with the light coming almost directly from my side. The first of these pictures (top left) shows how contrasty the resulting image is when the crocuses are photographed in this hard light, with some petals casting dark shadows onto others and the sunlit parts of the flowers appearing overly bright in comparison. For the second photograph (top right) I used a reflector. This has pushed quite a lot of light back into the image and lightened the shadows, but has by no means removed them completely. For the third photograph (bottom left) I used a diffuser, which has created a much softer light and eliminated all the shadows. It is a much more flattering light for such a delicate subject. However, it has caused the flowers to appear rather too blue, so I corrected this color cast in Photoshop by adding a little red (see page 50), which restored the flowers to their natural color. The result is the final image shown here (bottom right).

Nikon D2x, 105mm macro lens, ISO 100, f/9 at 1/320 (top left)

Nikon D2x, 105mm macro lens, ISO 100, f/9 at 1/400, reflector (top right)

Nikon D2x, 105mm macro lens, ISO 100, f/9 at 1/50, diffuser (bottom left and right)

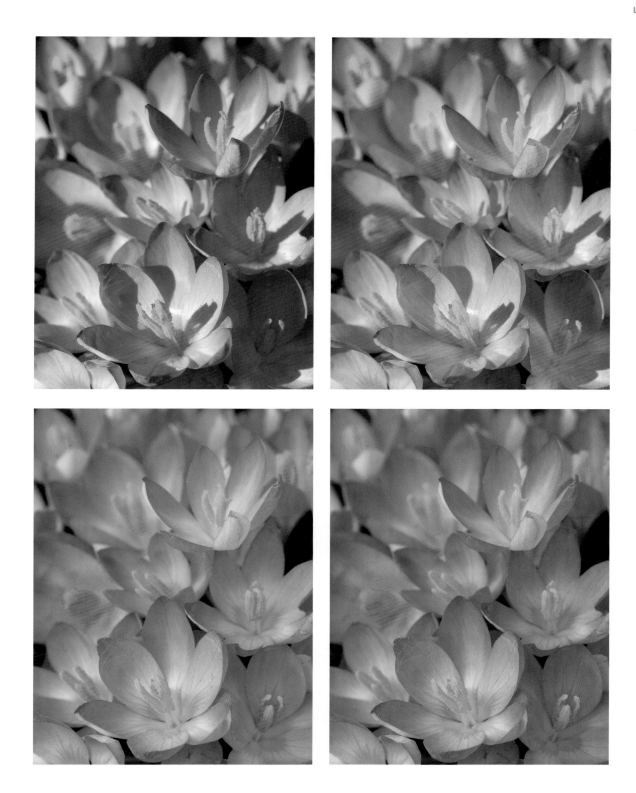

Light that is between hard and soft

Of course, not all light will fall into an exact category of being either hard or soft. Sometimes sunlight may be diffused by a very thin layer of cloud, and this light can be wonderful for photography of all sorts, and especially for photographs of flowers. Such light may be said to combine the best of both worlds—it gives a feeling of brightness and some sense of shape and dimension without creating problems of contrast between light and shade. On a day with a clear blue sky and clouds, you can sometimes wait for the sun to be just at the edge of a cloud for a moment of "in-between" lighting.

Water lily
I would not have wanted hard sunlight on this water lily, as it would have bleached out the delicately colored petals. Luckily the sun was slightly diffused by a thin layer of cloud, so I was able to take a photograph of the lily gently lit by the sun with no distracting areas of dark shadow.
Nikon D2x, 80-400mm lens at 400mm, ISO 100, f/8 at 1/250 sec

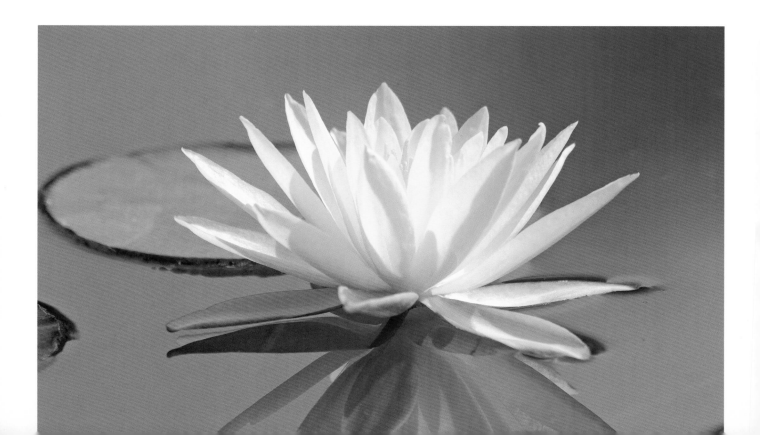

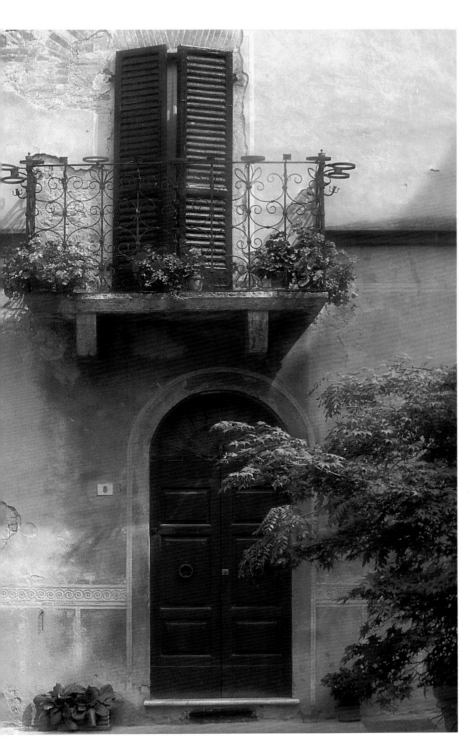

Doorway, Tuscany

I was delighted when I came across this door and balcony, as there was nothing modern to detract from it–so often such scenes are spoiled by plastic flowerpots, washing lines on the balcony, or wiring around the doors. It was a fairly windy day and clouds were scudding across the sun, so I was able to observe the effect on the scene of both full sun and full shade. In bright sun there was a harsh line between light and shadow, dividing the image diagonally from top right to bottom left, but when the sun was completely obscured the image lacked sparkle. I waited for a moment when the sun was just at the edge of a cloud and the scene was lit by diffused sunlight–the line between light and shadow was now soft enough not to be too distracting, and the gentle sunshine lifted the picture and added a bit of sparkle to the balcony doors.

Nikon F100, 28–105mm lens, Fuji Velvia 50

Soft light

When the sun is covered by cloud the light is soft and even. The advantage of this gentle light is that there are no shadows and there is no need to worry about contrast between light and dark areas; on the other hand, soft light will not emphasize dimension and shape in the way that hard light does. Because of the lack of contrast, soft light will provide better detail in all areas of the image, and light or delicate colors will not be burnt out. Even within the category of soft light, there is quite a range of difference between the light on a day with white cloud cover that is not too dense—which can provide a lovely gentle light for photography—and that on a day with thick, heavy, gray cloud, when there really is no light to lift an image at all. Although instinctively I still react more positively to a bright, sunny day, I know from experience that at least fifty percent of my favorite images have been taken when the light has been soft and overcast.

Almond blossom, Mallorca

This pair of photographs illustrates the remarkable difference that the type of prevailing light can make to a scene. I first came upon these trees just after it had been raining, and the sky was very overcast. Both the almond blossom and the wildflowers growing beneath the trees are pale colored and delicate, and the gentle light has shown them to their best advantage (bottom right). I returned a few hours later after the sun had come out and took a comparison picture (top right). You can see that the blossom and the wildflowers appear less soft and lush, the trees appear more twiggy, and there are unattractive shadows on some of the trunks and branches. Incidentally, I prefer the dark color of the tree trunks in the first picture, which is partly due to the rain—they are not so attractive in the second picture when they have dried out!

Nikon D2x, 80–400mm lens at 86mm, ISO 100, f/18 at 1/60 sec (top right)

Nikon D2x, 80–400mm lens at 98mm, ISO 100, f/18 at 1/2 sec (bottom right)

Pink flower

Flowers are very often better photographed in soft light, especially if they are light in color or have delicate petals. The pastel-colored petals of this little pink flower would have been burnt out in hard sunshine, but are shown to their best advantage in this lovely soft light.

Nikon D2x, 105mm macro lens, ISO 100, f/5.6 at 1/180 sec

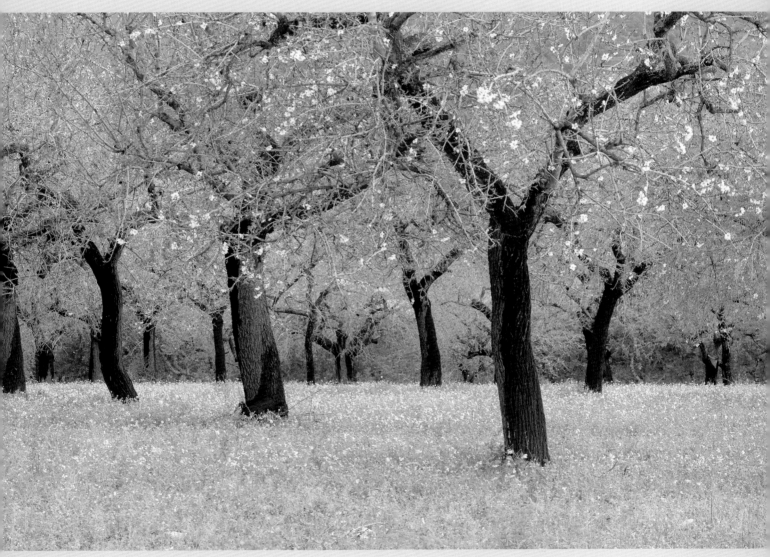

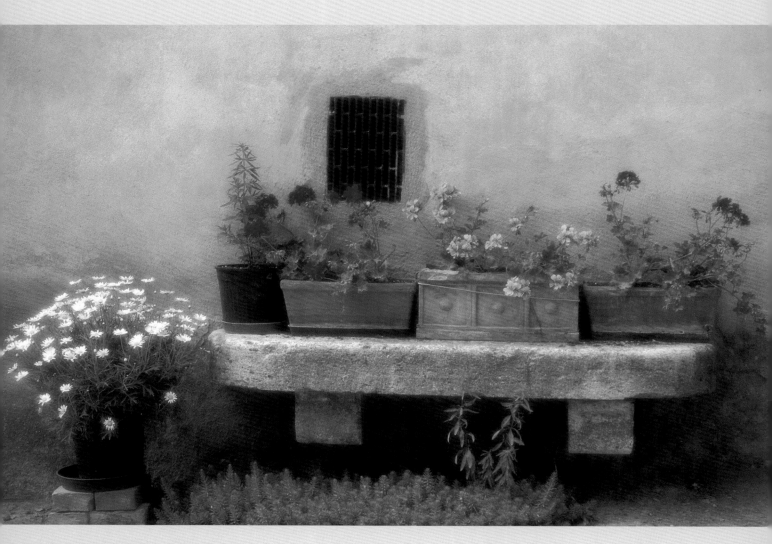

Stone bench with flowers, Tuscany

I found this lovely old stone bench outside a house in Tuscany. I was glad
the day was overcast, as bright sunlight would have created hard shadows
within the scene, especially underneath the bench. The lovely Italian pastel
colors are enhanced by the soft light.

Nikon F3, 28–105mm lens, Fuji Velvia 50

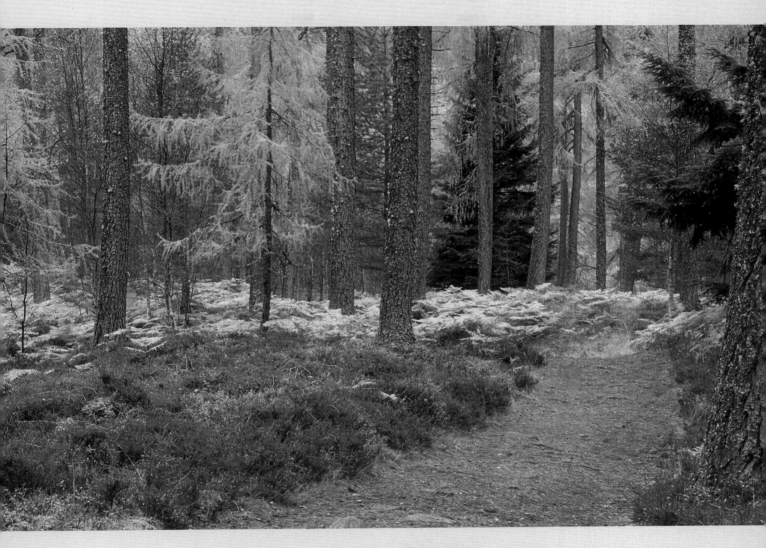

Scottish woodland

I love walking through woods on a bright day when the sunlight is filtering through the trees and dappling the scene with pools of light and shade, but the effect of this type of light does not translate very well into a photograph. Our eyes continually compensate for the differences between the light and dark areas, but the camera cannot do this in the same way, and an image taken in such conditions will be very contrasty. In general, woodlands are much better photographed on an overcast day when the soft light gives an even illumination. In this photograph of a wood in Scotland, the subtle colors are seen at their best in the even light.

Nikon F3, 28–105mm lens, Fuji Velvia 50

Front light

Light that comes from behind the photographer and falls directly onto the subject being photographed is known as front light. It is seldom the most interesting light to use in a photograph, as it doesn't reveal form and texture in the way that sidelighting does, nor does it create exciting light effects in the way that backlighting can do, so it can result in a rather flat, two-dimensional feel to the image. However, because it only causes shadows behind the object being photographed, the evenness of front light can be good for revealing detail and color.

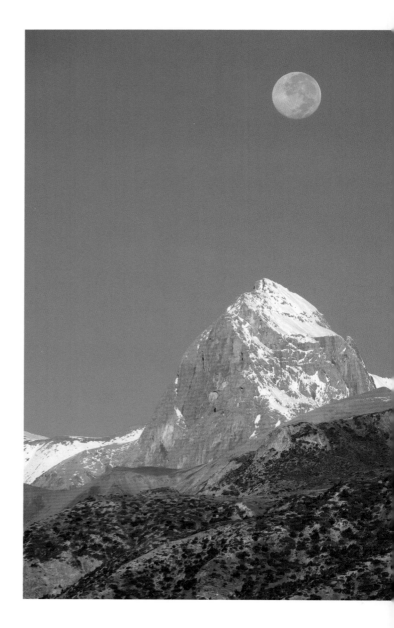

Moon and peak, Nepal

It was just after sunrise when I took this photograph of the moon suspended above a peak in the Himalayas. The light was coming from directly behind me, and clearly I had no chance of moving and finding a different angle on the distant mountain before the moon sank behind it. Because the peak is frontlit, it completely lacks any three-dimensional quality and looks very flat. The sense of flatness is emphasized by the fact that I used a telephoto lens (see page 100). With the sun being so low, if it had been coming from the side instead of behind me it would have revealed the texture in the scene wonderfully.

Nikon D2x, 18-200mm lens at 200mm, ISO 100, f/10 at 1/160 sec

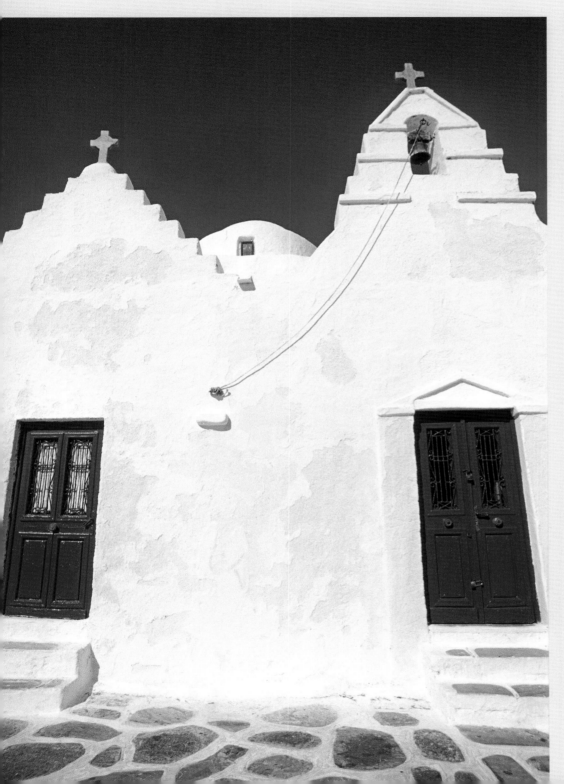

Greek church
The strong front light on this church has produced a flat, two-dimensional feel in the image. Together with the white walls and the saturated colors, this has given a strong, graphic feel to the photograph.
Nikon F3, 24mm lens, Fuji Velvia 50

Side light

Light that is coming from the side of the photographer will generally be much more interesting to work with than front light. Because it lights one side of an object and casts the other side into shadow, it reveals the shape and the three-dimensional appearance of that object. This is almost always of benefit in a landscape photograph, revealing the contour and form within the scene. As we have seen, very bright, low sidelighting can make some types of scenery appear almost abstract in a photograph. A more diffused side light will have a less dramatic effect, gently revealing the form of the land by illuminating one side—and because the light is softer, the shadows will be less harsh and black.

As light coming from the side skims over the surface of an object, it will reveal its texture much more clearly than if the object is flatly frontlit. However, the drawback of side-lighting is that the shadows it causes can be too harsh in a photograph of a delicate or gentle subject. Sometimes this problem can be alleviated by using a reflector to push illumination back into the shadowed areas (see page 58).

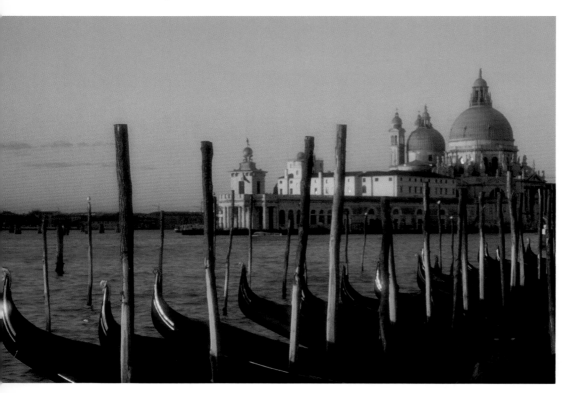

Gondolas and San Salute at dawn, Venice
Not all sidelighting has to come from a 90-degree angle. In this photograph the light came from a 45-degree angle, about halfway between front light and side light. It still provided plenty of three-dimensional modeling on San Salute, as well as illuminating the posts with a lovely warm light and painting the prows of the gondolas with gold.
Nikon F100, 28-105mm lens, Fuji Velvia 50

Red dahlia

In the first of these photographs (left), the dahlia is frontlit and the light is very unflattering to the flower, failing to reveal any shape or form. It is also falling directly onto and brightly lighting the rather unattractive foliage behind the flower. For the second photograph (below), I changed my position so that the light came from the side, and this made a dramatic difference to the resulting image. The side light reveals much more shape and texture in the flower, rim-lighting each of the petals. Also, it is no longer falling directly onto the foliage behind the dahlia, so it appears darker and no longer draws the eye away from the flower.

Nikon D2x, 80–400mm lens at 360mm, ISO 100, f/9 at 1/60 sec
Nikon D2x, 80–400mm lens at 330mm, ISO 100, f/9 at 1/50 sec

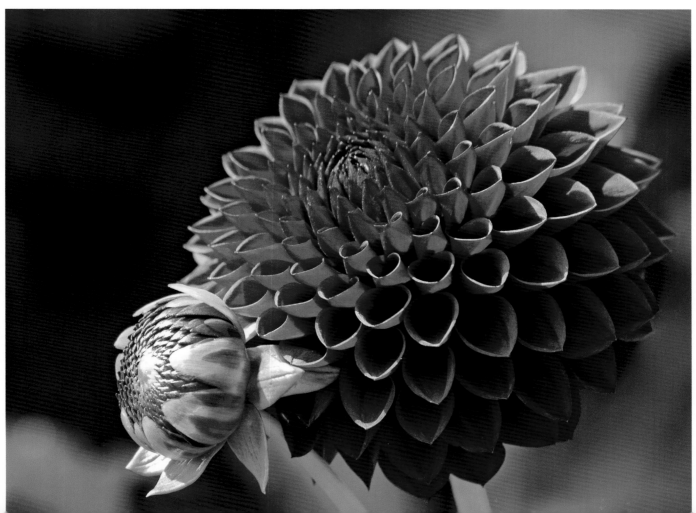

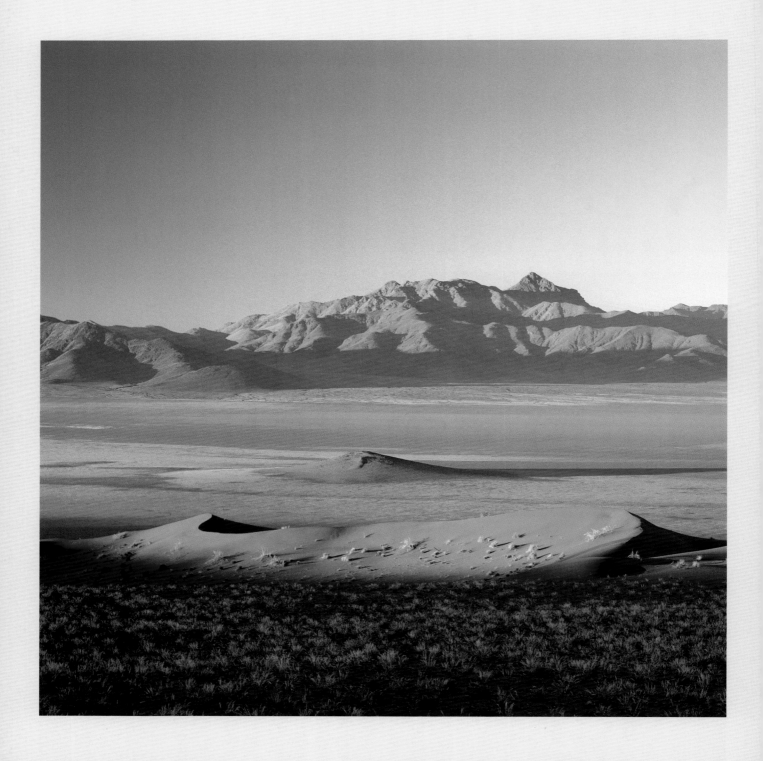

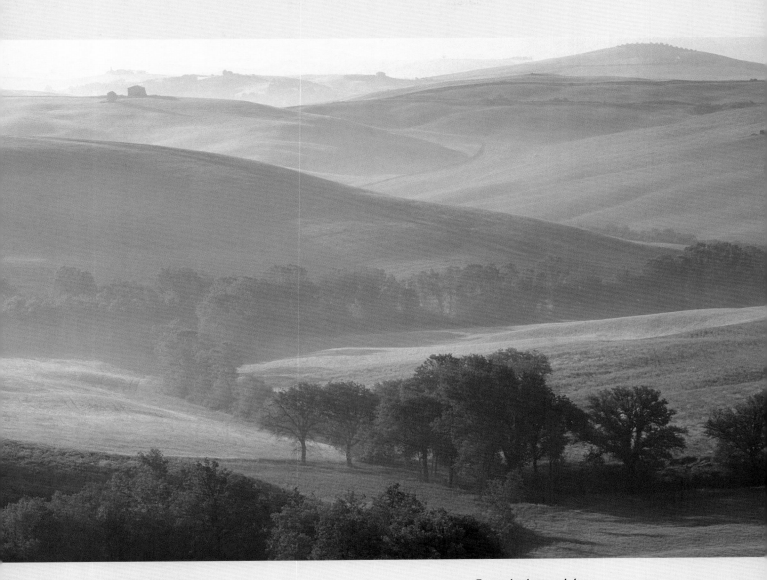

Chateau Plain at dawn, Namibia (left)

Although getting up at 4.30 am was no fun at all, it was more than worth it to be standing at the edge of this beautiful plain in Namibia as the sun rose. The light is strong and comes directly from the side, and you can see how it reveals and emphasizes the form and shape in the landscape. Notice how the extremely low angle of the sun has resulted in very long shadows.

Hasselblad 500C, 80mm lens, Fuji Velvia 50

Tuscan landscape at dawn

Because it is softened by a slight mist, the side light in this picture is much gentler than the light in the photograph of Chateau Plain. Nevertheless, the subtle areas of light and shadow are sufficient to show the contours of the land. As in the photograph of San Salute (see page 68), the light comes from an angle of approximately 45 degrees, this time about halfway between side light and back light.

Nikon F3, 28-105mm lens, Fuji Velvia 50

Back light

When light comes toward the photographer from behind the subject it is known as backlighting. It can produce some beautiful effects, especially when the subject being photographed is translucent, allowing the light to shine through it and illuminate it from behind. An object that is not fully translucent may still have a striking rim-lit appearance when backlit. However, bear in mind that the part of a backlit subject that is facing you will have no light falling on it, and therefore the detail and color in it will not be revealed. A solid object that takes up a large proportion of the image area will generally not benefit from backlighting unless it has an interesting shape and your aim is to create a silhouette.

FLARE

When you photograph a backlit subject, the sun comes directly toward your camera, and you need to beware of light falling on the front element of your lens. This will cause flare, which degrades the image and can result in pale, washed-out patches or bright polygonal shapes appearing in the photograph. Flare can sometimes be avoided by using a lens hood, but depending on the angle of the light this may not be sufficient, in which case you will also need to shield the lens with your hand or a piece of card.

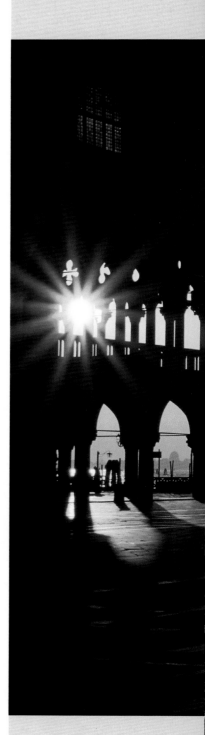

St Mark's Square at sunrise, Venice
On a visit to Venice in January, the sun rose at just the right place to appear through the columns of the Doges' Palace as it climbed. It would not normally be possible to take a picture directly into the sun in this way, as it would be far too bright, but the columns masked the sun sufficiently for me to take the photograph, and also created a sunburst effect as the sun shone through them. Note how the translucent glass of the lamps shows some color, while the other solid objects are silhouetted.
Nikon F100, 28–105mm lens, Fuji Velvia 50

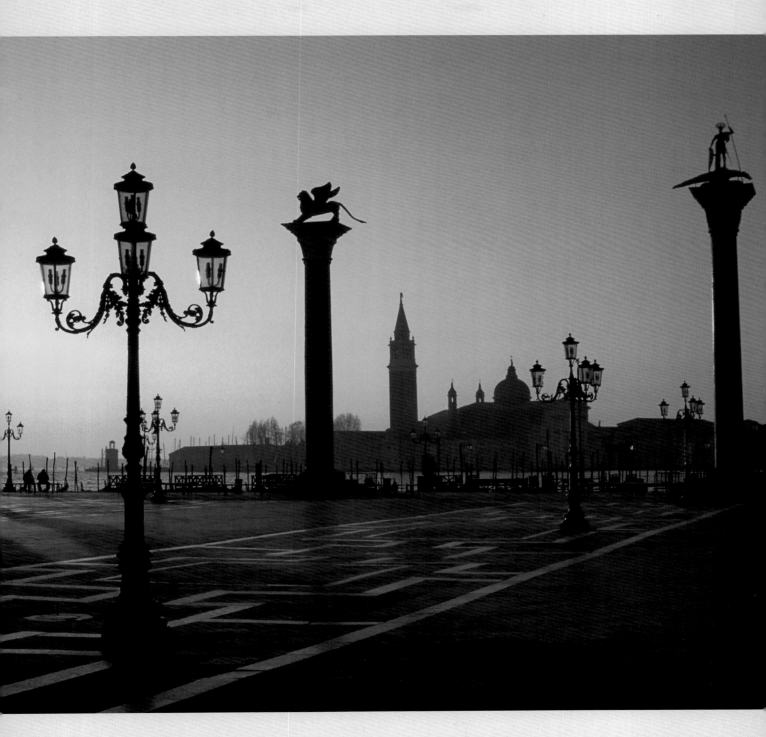

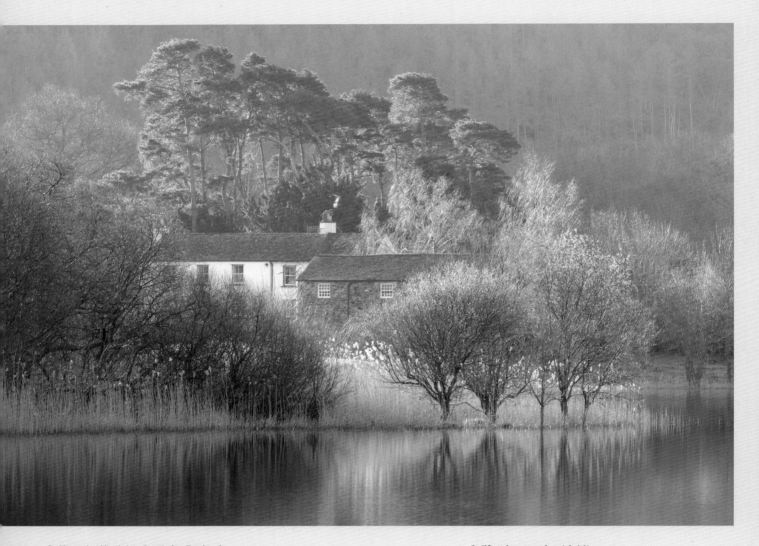

Cottage by the lake, Cumbria, England

The backlighting in this photograph is gentler than in the picture of
St Mark's Square on page 73, but is nevertheless crucial to the effect
of the image. The light gently touches the tops of the trees and
illuminates the translucent reeds, giving them a lovely golden glow
that is reflected in the water. The angle of the sun was such that even
my lens hood was unable to shield my lens from light, but because
I had the camera on a tripod I was able to use one hand to help shield
the lens while releasing the cable release with the other.

Nikon D2x, 80-400mm lens at 145mm, ISO 100, f/10 at 1/20 sec

Californian poppies (right)

Many varieties of flowers make excellent subjects for backlighting.
These poppies looked fairly uninteresting when frontlit, but their
translucent petals were transformed when the sun shone through
them from behind.

Nikon D2x, 80-400mm lens at 400mm, ISO 100, f/5.6 at 1/400 sec

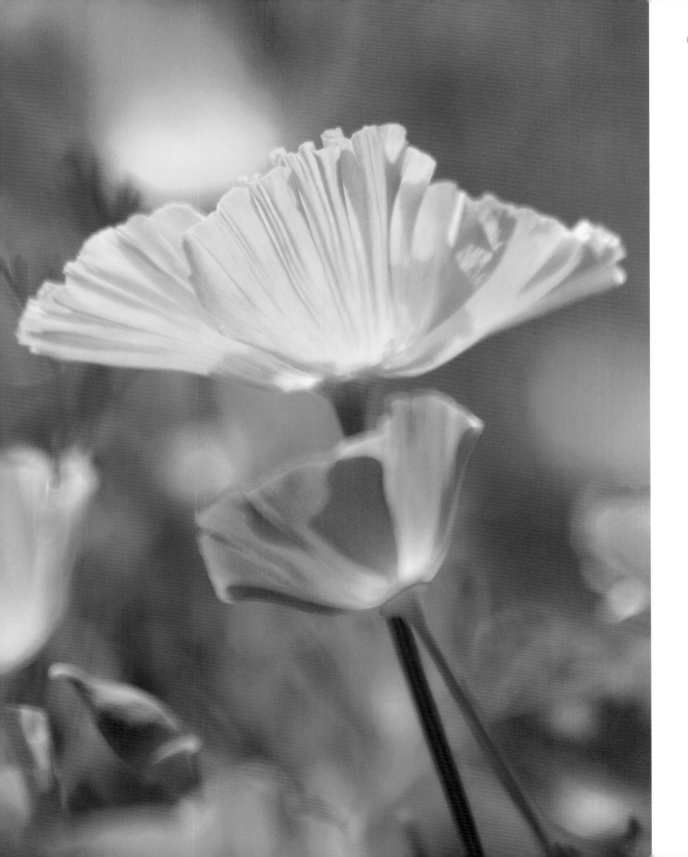

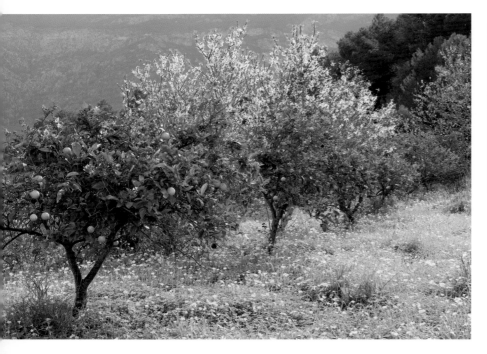

BRACKETING

Strong backlighting can sometimes fool your camera's meter and lead to underexposure of the photograph. If in doubt, take a few exposures using the camera's suggested reading and bracketing between one and two stops over that.

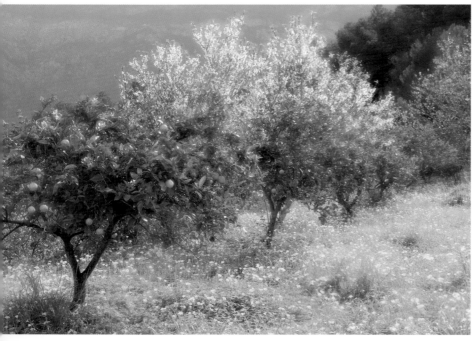

Blossom and oranges, Mallorca

Some backlit subjects lend themselves well to the use of a soft-focus filter, which spreads and diffuses highlights in a photograph. In the second of these images (bottom), the light coming through the white blossom and the highlights on the oranges and foliage have been enhanced by a soft-focus filter.

Nikon D2x, 28–70mm lens at 38mm, ISO 100, f/10 at 1/100 sec

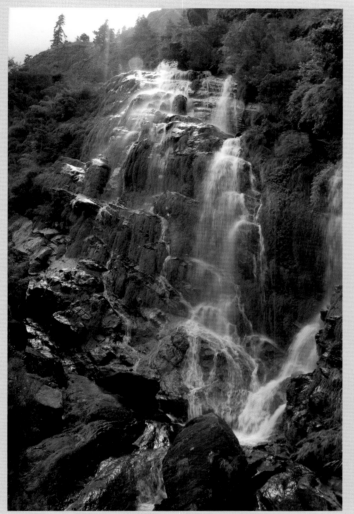

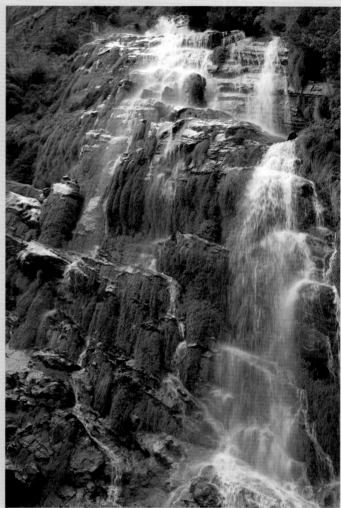

Waterfall

I was facing directly toward the sun when I photographed this waterfall, and in the first image (above left) the light has fallen onto the front element of my lens and caused flare in the form of a large purplish patch at the top of the image and a line of bright highlights coming down through the center. For the second image (above right) I shielded the lens with my hand so that the photograph would not be degraded by flare. I also zoomed in slightly to exclude the bright patch of sky at the top of the photograph.

Nikon D2x, 18-200mm lens at 18mm, ISO 100, f/16 at 1/20 sec (above left)
Nikon D2x, 18-200mm lens at 32mm, ISO 100, f/10 at 1/40 sec (above right)

Changing light

On a day with a clear sky or total cloud cover, the light is not likely to change very rapidly; but if you are out photographing on a day with mixed sun and cloud, you need to remain aware of changes in the light conditions. If you are photographing a close-up subject, this will be fairly straightforward—your subject will either be in sun or in shade— but if you are photographing a wider view, such as a landscape, the changing light may have more of an effect. Imagine a wide landscape and a sky with puffy white clouds—when the sun is out, those clouds cast their individual shadows on different parts of the land below, and the distribution of these shadows can make quite a difference to your photograph. As the clouds move, their effect on the landscape will change, often with quite striking results. For instance, if your landscape has a focal point such as a lonely cottage, and you can wait for a moment when the cottage is lit by the sun but the landscape around it is in shadow, you will have a much more dramatic photograph than you would if the whole scene were brightly lit.

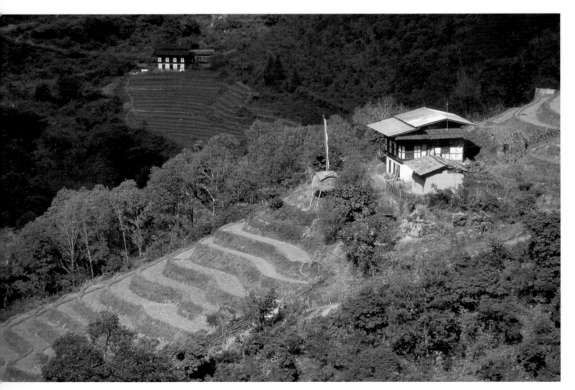

House and terracing, Bhutan
This photograph was taken on a day when fairly large clouds were moving across the sky. I waited until they were in such a position that cloud shadow covered the more distant terraces in this scene, while the subject house and terraces were brightly lit. The result was that the darker background "sets off" the subject.
Nikon F100, 28–105mm lens, Fuji Velvia 50

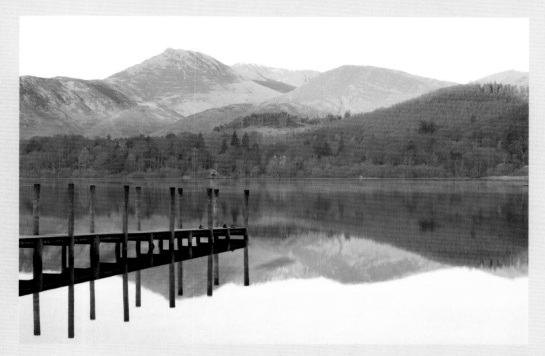

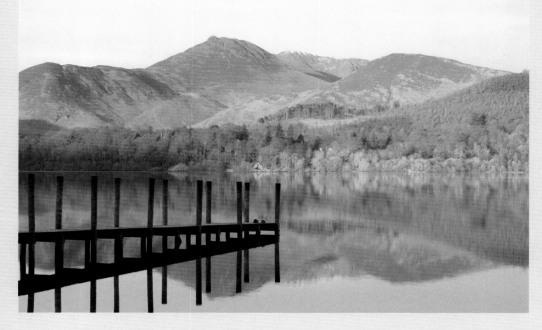

**Derwentwater at dawn,
Cumbria, England**
Even on a clear day, the effect of the
light on a landscape will change quite
rapidly at sunrise and sunset. These two
photographs were taken only 15 minutes
apart. In the first (top), the sun has not
quite risen above a hill behind me, so
there is an area of shadow on the hill in
my photograph, and in the reflection of
that hill. In the second image (bottom),
the sun has lifted clear of the intervening
hill and the whole image is now lit. The
color temperature of the light is slightly
less warm in the second photograph, and
there is more blue in the sky. Those 15
minutes made quite a dramatic difference
to the resulting image.
**Nikon D2x, 28-70mm lens at 52mm,
ISO 100, f/22 at 1.6 sec** (top)
**Nikon D2x, 28-70mm lens at 52mm,
ISO 100, f/20 at 1/2.5 sec** (bottom)

Color temperature of light

We can easily observe the effects that the various types of light have on a subject when we are considering hard light or soft light, or front, side, or backlighting. However, we may not be so readily aware of another effect that light has on our images, and this is the result of the color temperature of the light. Different types of light—natural daylight, tungsten, fluorescent, and so on—have different color temperatures; in addition, daylight itself has a wide color temperature range, which is dependent on the weather conditions and the time of day. Our eyes and brains automatically compensate for the different color temperatures so that we see different types of light as being fairly similar, unless we really stop to think about it. If we are attentive to this, we may notice some differences. Imagine, for instance, being outside on a cold, snowy day and looking at a house with tungsten lights on inside glowing through a window—that window will look like a square of warmth compared to the light outside. This is because tungsten light is much "warmer" than daylight, especially daylight on a cloudy day, which has quite a cold cast.

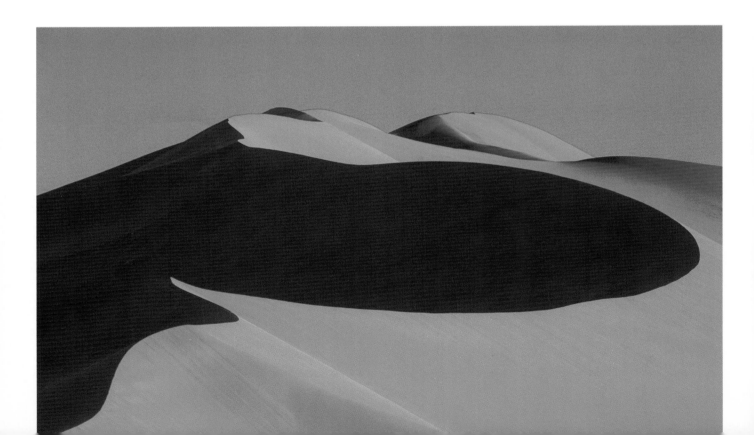

Sand dunes at sunrise, Namibia

These photographs of sand dunes were taken at Sossusvlei in Namibia at sunrise. The hard, low sidelighting has created a very graphic image, as it brilliantly lights one side of the dunes, leaving the other side in almost black shadow. You can see that there is quite a difference in the color of the sand in each of the images—my exposure settings remained the same for all three, and the difference is entirely due to the changing color temperature of the light as the sun rose higher in the sky. The earliest image (far left) has the warmest light, making the dunes look almost red; then, as the sun rose higher, the light became less warm and the sand looked orange (top left) and then, eventually, yellow (bottom left). By the time the sun was overhead, the sand would have appeared quite a pale yellow, and all the definition of shape caused by the low sidelighting would have been lost.

Nikon F3, 200mm lens, Fuji Velvia 50

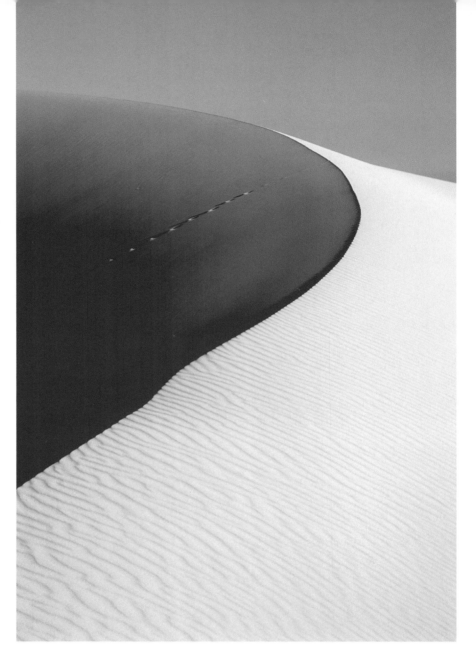

White sand dune, South Africa

This sand dune was white, and the photograph was taken in the late afternoon. Where the sun is lighting the sand, it appears white in the image, as it did to the eye; but the shadowed area, which looked merely gray to the eye, has taken on a blue cast in the photograph, as the color temperature of light in a shaded area on a sunny day is cool. Very often a cold, blue cast is not considered desirable, but in the case of this very abstract image I enjoy the almost indigo tones of the shadow in conjunction with the white of the sand and the blue of the sky.

Nikon F3, 200mm, Fuji Velvia 50

Although we tend not to notice the effects caused by light with different color temperatures, the film or digital sensor in a camera will accurately record the temperature of the light and its effect upon our subject, so a photographer needs to be aware of how this will affect the resulting image. The color temperature of sunlight on a bright day will be warmer at the beginning of the day, gradually getting cooler as the sun reaches its highest point in the sky, and warming again as the sun goes back down. So a scene photographed at sunrise will have a much warmer, redder cast than it will in a photograph taken at midday, which will have cooler, bluer tones. A photograph taken in open shade on a sunny day will also have a cool cast, as will one taken on an overcast day.

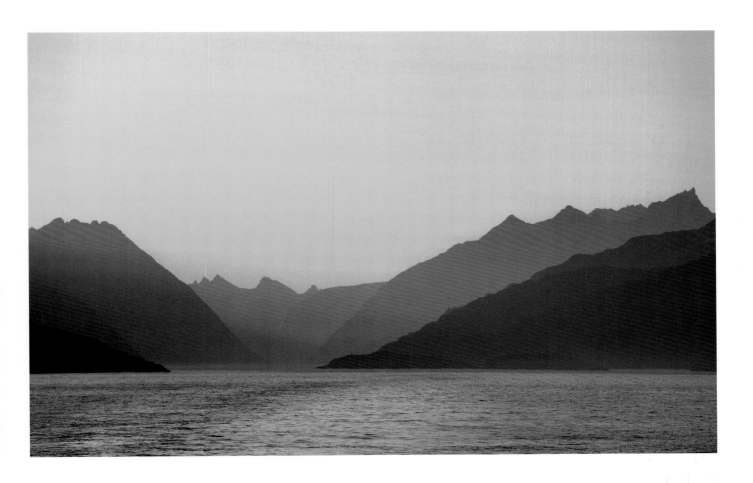

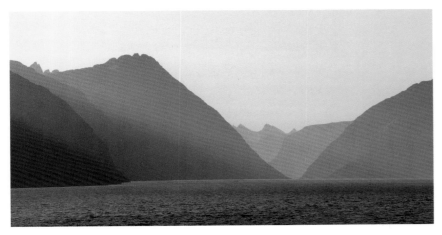

Last light of the day, Prins Christian Sund, Greenland
These two photographs were taken from the deck of a ship
sailing out of Prins Christian Sund as the evening approached
and the sun went down behind the mountains. The images were
taken about 35 minutes apart, and you can see in the second
image (above) how the warmer color temperature as the sun
went down has given a golden glow to the sky, a glow that
was not really noticeable to the eye at the time, but that was
recorded by the digital sensor.
**Nikon D2x, 18–200mm lens at 200mm, ISO 100,
f/8 at 1/180 sec** (top)
**Nikon D2x, 18–200mm lens at 135mm, ISO 100,
f/13 at 1/200 sec** (bottom)

White balance

On page 42 we saw how warm-up filters can be used when shooting with film to remove a cool color cast caused by the color temperature of light. These filters are unnecessary when photographing digitally, as the white balance settings on a digital camera offer a range of adjustments that can be used to deal with different color temperatures.

The white balance menu on most digital cameras will offer an Auto setting as well as settings for a variety of lighting situations. The Auto setting will often provide a reasonable result, and you can always make fine adjustments to the color temperature later in Photoshop. However, if you are aware that you are photographing in a lighting situation that is likely to result in an undesirable color cast, you can avoid this by using the appropriate white balance setting. The two settings that you will use most often in natural-light situations are Cloudy and Shade—the latter referring to photographing in a shaded area on a sunny day. The effect of these settings will be to counteract the cool, blue cast caused by the color temperature of the light by restoring a bit of warmth to the resulting image.

CREATIVE COLOR CASTS

You may decide not to compensate for a color cast but instead to use it for creative effect. If you are photographing a snowy landscape under a cloudy sky, for example, a cool, blue cast will be quite appropriate, and you may not want to add warmth by using the Cloudy white balance setting. If in doubt, take the photo using two or more different settings and decide which one you prefer at a later stage.

Houses and boat, Burano, Italy
These vividly painted houses were on the shady side of the canal on a bright sunny day, so I knew that there was likely to be a cool, blue cast in my photograph. In the first photo (above) I set the camera's white balance to Auto and in the second (right) to Shade. The colors are much warmer in the second photograph, equating more closely with the way the scene appeared to my eye.
Nikon D2x, 18-200mm lens at 60mm, ISO 100, f/14 at 1/30 sec

Enhancing lighting in Photoshop

**Photoshop and other image-editing programs provide
many different options for altering the appearance of
the light in your photographs. We have already examined
how to adjust a color cast resulting from the color
temperature of the light (see page 50); here, I am going
to look at two of the most useful ways of adjusting the
lighting in an image.**

LEVELS

The first of these techniques is Levels, which deals with the
range of light and dark tones in an image. Generally speaking,
a good photograph should have a full range of tones from
white through to black. When I begin to work on a photograph
on my computer, one of the first actions I take is to check the
Levels. To do this, click on Enhance>Adjust Lighting>Levels
(Photoshop Elements) or Image>Adjustments>Levels
(Photoshop). A histogram will appear—a graph that looks rather
like a black mountain—and this shows the distribution of light
and dark tones in your photograph. If the image contains a full
range of tones, the edges of the black histogram will extend
right to the edges of the graph. If they do not, you can make
adjustments using the triangular sliders under the graph.
If your histogram does not reach the left edge, drag the black
slider inward until it reaches the edge of the black area.
If necessary, do the same with the white slider and the right
edge. Make sure the Preview box is checked so that you will be
able to see the effect of these adjustments on your image as
you move the sliders—it should appear brighter and have better
contrast. When you are happy with your changes, click OK.

Rock and fall colors
The light was very flat when I took this photograph, and the resulting
image looked a little dull (top). It has been easily improved by
tweaking the levels in Photoshop (above).
Nikon D2x, 18-200mm lens at 112mm, ISO 100, f/8 at 1/90 sec

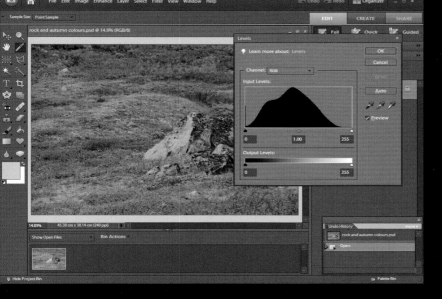

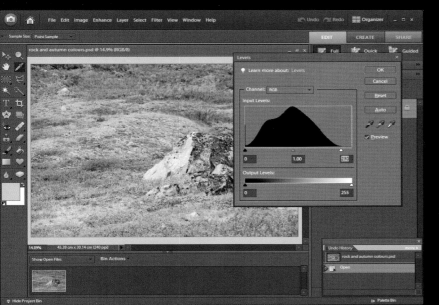

When I looked at the levels in this image the histogram did not reach the edge of the graph on the right. To adjust the levels, I clicked on the white slider and moved it in until it reached the edge of the black histogram.

If the histogram already shows a full range of tones in your photograph but you still feel that it is either too light or too dark overall, the middle slider can be moved to the left or right to lighten or darken the midtones. Again, make sure the Preview box is checked so that you can evaluate the changes as you make them.

SHADOWS/HIGHLIGHTS

As an alternative to using levels, the Shadows/Highlights tool is an easy way of making adjustments to deal with unwanted dark areas in a photograph. Although the control can also be used to reduce overbright highlights, I find it much more useful for managing shadows and bringing detail back into areas of the picture that are too dark. The tool always opens with a default setting that lightens the shadows by 25 percent, but I usually find that this is too much—sometimes just 3 or 4 percent can make a striking difference to your photograph.

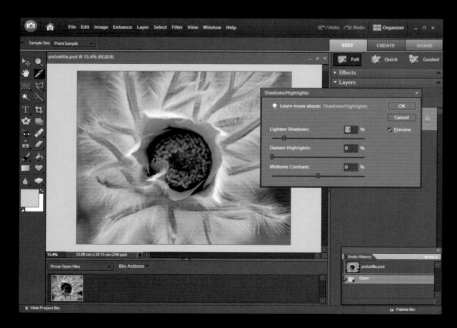

To open the dialog box, click on Enhance>Adjust Lighting>Shadows/Highlights (Photoshop Elements) or Image>Adjustments>Shadows/Highlights (Photoshop). The dialog box has three sliders; we will use the Lighten Shadows slider (Shadows in Photoshop). If the Preview box is checked you will be able to see the effect this has on your image. If this is too much, adjust the slider to reduce the effect—or increase it, if you want to lighten an image even more. When you are happy with your adjustments, click OK.

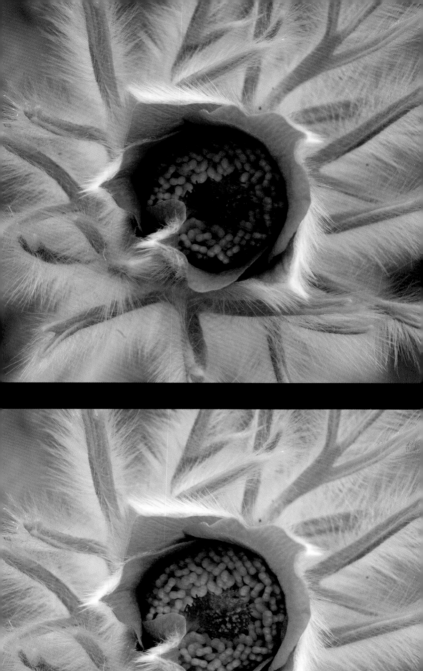

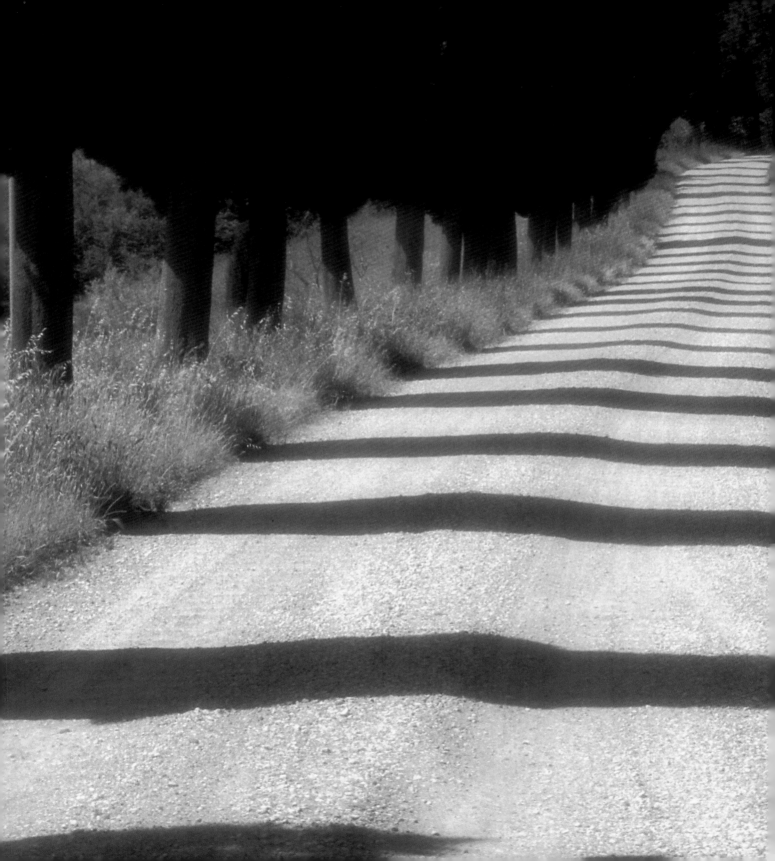

COMPOSITION

In the frame

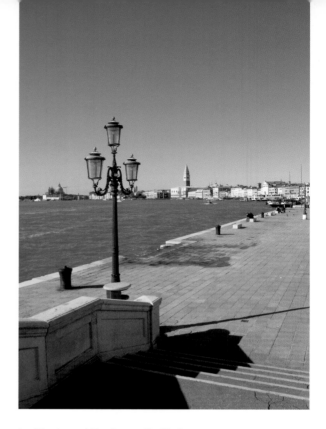

Whenever we compose a photograph we make a series of decisions about which of the elements in a scene to include in the image, which to exclude, and how to arrange these elements within the frame; these decisions will be influenced by the shape and the color of these objects and by the type of light that is falling on them. We then make further choices about which focal-length lens to use and which aperture to select. Some of our decisions may be conscious and others may be subconscious; some may follow the compositional "rules" and others may be intuitive; and they all come together to create our composition. It's not easy to offer a definition of what makes a "good" composition, but when I look at my photographs I know that a composition I am pleased with is one in which the arrangement of shape, color, light, and form seems to be harmonious and balanced.

COMPOSITIONAL CONSIDERATIONS WITH DIFFERENT FOCAL LENGTHS

The decision about which lens to use to photograph a subject will make an enormous difference to the resulting image. Since there are now so many high-quality zoom lenses available, a photographer may carry a range incorporating every possible focal length from wide to telephoto—for example from 24mm to 300mm. The choice of focal length affects not only how large or small the subject appears in the image, but also the way the perspective and sense of depth appear; it will also affect the amount of background included behind a subject.

In 35mm film camera terms, a standard lens is 50mm; lenses with a shorter focal length—typically 35mm or less—are wide-angle, and lenses with a longer focal length are telephoto.

Looking toward the Campanile, Venice

I took this series of photographs without changing my position. My camera was mounted on a tripod and I used a zoom lens of 18–200mm. The difference in the result between one end of the zoom lens and the other is quite dramatic. Because my camera's sensor has a cropping factor of 1.5x, the photograph shown here taken with my zoom set at 34mm is effectively a standard lens picture.

Nikon D2x, 18–200mm lens at 18mm, ISO 100, f/22 at 1/40 sec (above)
Nikon D2x, 18–200mm lens at 34mm, ISO 100, f/22 at 1/40 sec (top left)
Nikon D2x, 18–200mm lens at 65mm, ISO 100, f/22 at 1/45 sec (top right)
Nikon D2x, 18–200mm lens at 130mm, ISO 100, f/22 at 1/60 sec (bottom left)
Nikon D2x, 18–200mm lens at 200mm, ISO 100, f/22 at 1/80 sec (bottom right)

If you are using a digital camera, the effective focal length of your lens may be affected by the size of your sensor. Many DSLRs have cropped sensors, which effectively increase the focal length of any lens used by an amount that depends on the size of the sensor. If a sensor has a cropping factor of 1.5x, the focal length will be multiplied by 1.5, meaning that, for instance, a 50mm lens will in effect become a 75mm lens.

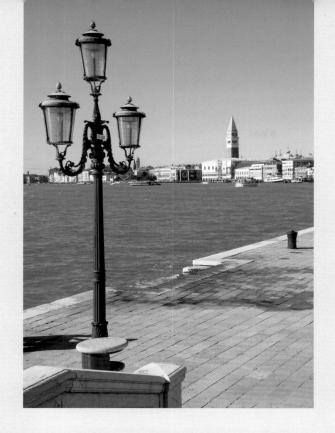
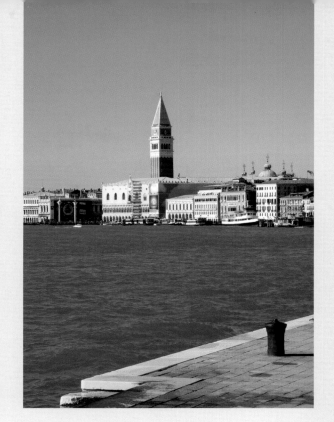
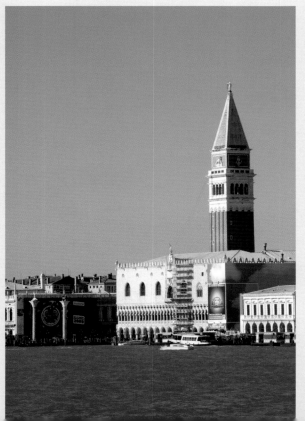
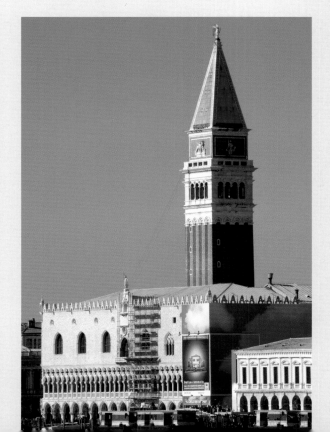

Using wide-angle lenses

A wide-angle lens includes a wide area of view in your photograph and increases the feeling of space and distance. It exaggerates the perspective of a scene, making objects close to the camera appear much larger than more distant objects, enlarging the apparent distance between them and pushing the horizon away. If you photograph something close to you—a flower, for example—with a wide-angle lens, you will include a greater area of the background behind it than you would if you photographed it with a telephoto lens. When photographing a landscape, a wide-angle lens will include a large area of sky or foreground or both, depending on the angle of the camera. This can be wonderful for making pictures with impact and emphasizing an interesting foreground or a beautiful sky; on the other hand, if there is nothing particularly attractive in the foreground or the sky, you will have a large area in the resulting image with no interest or information in it.

WIDE-ANGLE AND DEPTH OF FIELD
Wide-angle lenses generally give a good depth of field, so in most situations you should be able to have everything sharp in the image from front to back, which is usually desirable in this type of photograph. On the other hand, it will be more difficult to create areas of soft focus for artistic reasons, or to throw an unattractive part of the scene out of focus.

Parched earth, Sossusvlei, Namibia
In this photograph I wanted to emphasize the patterns and shapes formed by the dry, cracked mud. A wide-angle lens was the best option, as it made the foreground patterns very dominant in the picture and pushed the distant sand dunes farther away than they appeared to the eye. I adjusted the angle of my camera so that most of the frame would be taken up with the cracked earth and only a small amount of sky would be included.
Nikon F3, 24mm lens, Fuji Velvia 50

Reflected mountain, Umbria, Italy
This is one of my favorite wide-angle pictures because it illustrates the way you can achieve visual illusions with a wide-angle lens. The photograph was taken on the Piano Grande, a high plain in Umbria, in April, and at first glance it appears that the distant snowcapped mountain is being reflected in a lake. In fact, the water is only a puddle, a few inches deep. I lay flat on the ground to take the picture, and at such a low angle I could see the mountain reflected in the puddle; using a wide-angle lens made the most of this by increasing the apparent size of the foreground reflection. In my enthusiasm I didn't notice until later that the ground I was lying on was also extremely soggy!
Nikon F3, 24mm lens, Fuji Velvia 50

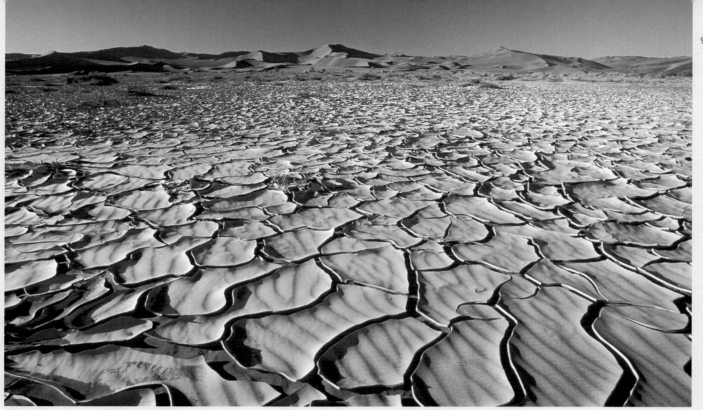

Bamburgh at sunrise, Northumberland, England
I had hoped for a slightly more dramatic sunrise when I went
out to photograph Bamburgh at dawn, but a wide-angle lens
made the most of the scene by emphasizing the sweep of the
clouds and including the reflection of sunlight in the water in
the foreground.
Nikon F3, 24mm lens, Fuji Velvia 50

The Annapurna Range at dawn, Nepal

One of the highlights of my trek in the Himalayas was a walk up to the top of Poon Hill in the pre-dawn dark to watch the first rays of the sun light the peaks of the Annapurna Range. I wanted to use a wide-angle lens to include as much of the width of the mountain range as possible, rather than zooming in on just one of the peaks, but as a wide-angle lens also includes a lot of foreground, it was impossible to avoid having the heads of several other sunrise watchers in the frame unless I tipped the camera right up and included a lot of sky, which was not particularly interesting. In the end, the only answer was to take the photograph as it was and crop it later in Photoshop. For more details about cropping, see page 152.

Nikon D2x, 18-200mm lens at 24mm, ISO 100, f/9 at 1/90 sec

Using standard lenses

A standard lens is often said to be the focal length that most closely approximates to our natural vision, because it includes a field of view that is not obviously wider or narrower than the one we would normally see, and it does not distort the perspective by either exaggerating or flattening it. A decade or two ago an SLR camera would usually come equipped with a standard lens, but now that prime lenses are largely giving way to zoom lenses, the standard focal length is more often found as part of a mid-range zoom lens.

Derwentwater at sunrise, Cumbria, England
For this photograph I had my zoom lens set at 28mm. Given my camera's cropping factor of 1.5x, this gave me an effective focal length of 42mm, which is just slightly to the wide side of standard. I took the picture almost at ground level on the shore of the lake to maximize the reflection in the water. I also took care to position myself so that the groups of stones in the water did not cut into the edges of the reflection.
Nikon D2x, 28–70mm at 28mm, ISO 100, f/9 at 1/20 sec

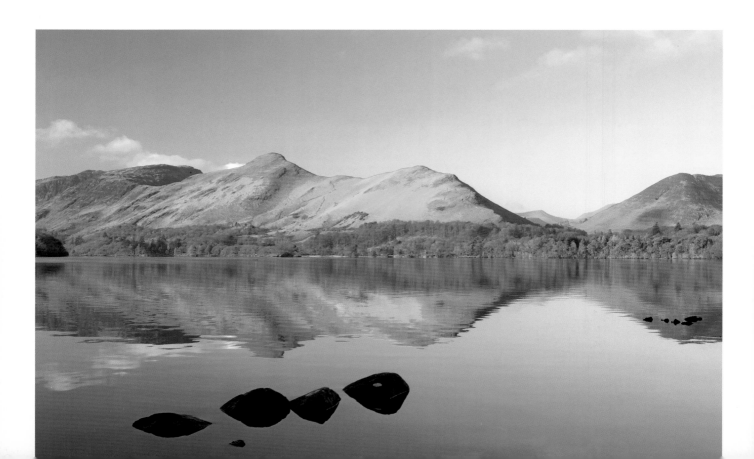

Piano Grande, Umbria, Italy

In June, the Piano Grande in Umbria is transformed by a beautiful carpet of wild flowers. I wanted to include the village of Castelluccio in my photograph as well as a swathe of flowers, and a standard lens was perfect for what I had in mind. The resulting image is a natural rendition of the view I saw, with no distortion of the perspective.

Hasselblad 500C, 80mm lens, Fuji Velvia 50

Using telephoto lenses

A telephoto lens has the effect of bringing distant objects closer and making them appear larger in your photograph than they do to the eye. Telephotos have a narrower field of view than either a wide-angle or a standard lens, and the longer the focal length of the lens you use, the more selective you can be about exactly what you include in your frame. If, for instance, you can see before you a house, some trees and fields, and a distant mountain range, the likelihood is that a wide-angle lens will include all of these and a standard lens will include most of them; but the more you increase your focal length, the more choice you will have about which of the elements to include in your image and which to exclude.

An important characteristic of telephoto lenses is that they compress and flatten perspective, diminishing the appearance of depth in a scene, in contrast to wide-angle lenses, which exaggerate perspective and increase the appearance of depth.

TELEPHOTOS AND DEPTH OF FIELD
In a photograph of the same subject from the same place, a telephoto lens will give you a much shallower depth of field than a wide-angle or standard lens. This can be a drawback if you want front-to-back sharpness, but on the other hand it allows greater opportunities for using depth of field creatively by using a wide aperture and throwing some areas of your image out of focus.

Geese on Derwentwater, Cumbria, England

I had been photographing Derwentwater just after sunrise
with my zoom lens at a standard length (see page 98), when
I heard the honking of geese and saw these birds coming in
to land on the lake. I liked the way the low sunlight was just
lighting the birds and their wake in the water, so I zoomed
to a short telephoto focal length to take a photograph of the
geese in the setting of the lake and mountains.

Nikon D2x, 28–70mm lens at 70mm, ISO 100, f/22 at 1/8 sec

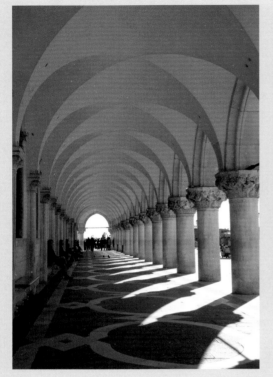

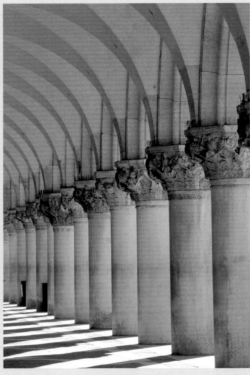

Arches and columns, Venice

I was attracted by the shapes in this arched colonnade, but with a standard lens it was impossible to make a pleasing picture, as the area was never clear of people. Zooming to the telephoto end of my lens gave more creative possibilities, as I could select and frame different parts of the scene more tightly. At 135mm the picture is much improved, but still includes some trash cans that detract from it; at 200mm I was able to exclude all extraneous clutter and make much more abstract images.

Nikon D2x, 18–200mm lens at 35mm, ISO 100, f/22 at 1/30 sec (top left)
Nikon D2x, 18–200mm lens at 135mm, ISO 100, f/22 at 1/30 sec (top right)
Nikon D2x, 18–200mm lens at 200mm, ISO 100, f/22 at 1/20 sec (bottom left and bottom right)

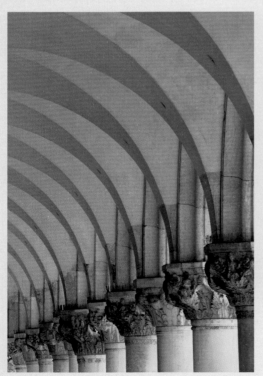

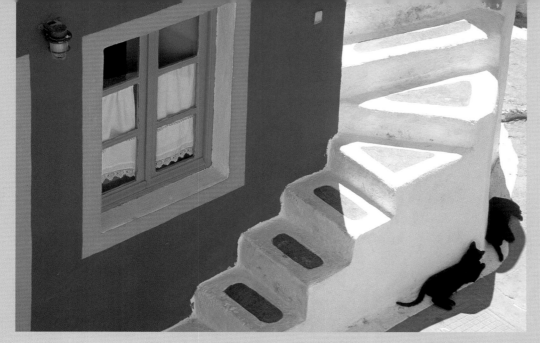

Greek steps

When I saw this wonderfully colored Greek house with a pair of black cats thrown in for good measure I was keen to photograph it, but the only viewpoint was from a street that was higher than the level on which the house was standing. The first of these pictures (top) was taken from that viewpoint with a standard lens, but I found the angle unsatisfying. For the second picture (bottom) I changed to a telephoto lens, which enabled me to frame more tightly and make a more abstract image of part of the steps and wall. In this tighter photograph the awkward angle of view is no longer a problem.

Nikon F3, 28–105mm lens, Fuji Velvia 50 (top)

Nikon F3, 200mm lens, Fuji Velvia 50 (bottom)

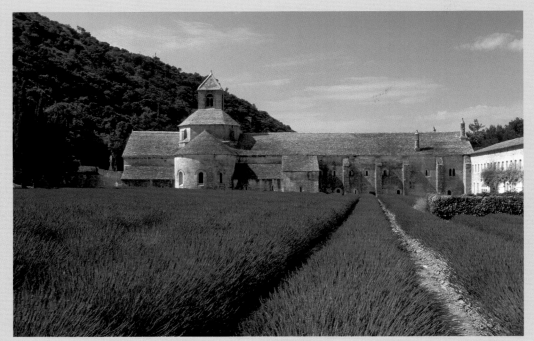

Senanque Abbey, Provence

When I arrived at this lovely abbey I first took the overall photograph showing the abbey in its surroundings with the rows of lavender leading toward it (top). However, I always like to take a more personal photograph as well as the general view, so I changed to a telephoto lens and took the second picture shown here (bottom). The telephoto allowed me to be much more selective about the elements I included in the frame, so I chose to frame my image in a way that emphasized the corresponding shapes of the arched windows and the rows of lavender.

Nikon F3, 28–105mm lens, Fuji Velvia 50 (top)
Nikon F3, 200mm lens, Fuji Velvia 50 (bottom)

Using macro lenses

A macro lens focuses at closer distances than a regular lens and allows a life-size (or larger) reproduction of the object photographed on film or sensor.

Macro lenses come in various focal lengths, most commonly around 50mm (standard) or 100mm or 200mm (telephoto). A macro lens is quite versatile in that it functions as a normal lens of that focal length as well as having the close-up capability; so a 100mm macro lens will act in just the same way as a regular telephoto lens in addition to being able to produce macro images.

When working at close focusing distances with a macro lens you will have a great deal of control over what to include and exclude in your image in the same way that you do when using a telephoto lens. You can be very precise with your framing, and a small movement to the left or right, or up or down, with the camera will make a very noticeable difference to the resulting image. Macro lenses offer great possibilities for making abstract photographs, as you can focus in close on a tiny part of something that becomes almost unrecognizable when seen out of its context. Natural subjects such as leaves, bark, or petals, or man-made objects like peeling paint or rusty metal, can provide amazing images when photographed up close with a macro lens.

Depth of field becomes very limited when photographing at close focusing distances, so you may have problems obtaining front-to-back sharpness in your photograph. To obtain the maximum depth of field, use your lens's smallest aperture and have the camera's film plane or sensor as parallel as possible to the object being photographed. Because a small aperture will necessitate a longer shutter speed, this will probably require the use of a tripod to avoid camera shake, and it may not be practical if there is any subject movement—for instance, if you are photographing a flower in windy conditions.

Alternatively, you can make the most of the limited depth of field by choosing a wide aperture and creatively using differential focus to have your subject sharp and the rest of the image softly defocused. This can be a lovely technique, especially with photographs of natural subjects such as flowers. It can transform a messy background, such as a tangle of leaves or twigs, into a gentle wash of color that enhances the subject instead of distracting from it. Turn to page 138 for more about depth of field.

TRIPODS AND COMPOSITION
Because both framing and focusing need to be very precise to make a good macro photograph, it's helpful to use a tripod. Tripods are often thought of as just aids to prevent camera shake, but they are also very useful for fine-tuning your composition. With your camera on a tripod you can take time to move your eye around the edges of the frame, checking for any unwanted elements, and really consider the balance of the shapes and colors within your image before pressing the shutter release.

Tulip

Although this unusual tulip did look good at a distance, I knew it would look even better up close, so I used my macro lens almost at its closest focusing distance. I wanted to find a composition that would show the pastel-colored outer petals parting to reveal the brilliant saturated red of the inner petals. I moved around the flower, looking for the most pleasing combination of color and shape, taking care to avoid any blemishes on the petals, as even tiny imperfections look glaringly obvious at this sort of magnification. Once I had found the composition I wanted I put my camera on a tripod, as I needed a very small aperture to get sufficient depth of field in the photograph.

**Nikon D2x, 105mm macro lens,
ISO 100, f/45 at 1.1 sec**

Red daisy with frost

The background behind this lovely frost-covered daisy
was rather messy, but thanks to the limited depth of field
available when working so close up with a macro lens, it
was easy to throw it out of focus so that it did not distract
attention from the flower.

Nikon D2x, 105mm macro lens, ISO 100, f/9 at 1/20 sec

Flaking paint

I found these wonderful shades of flaking paint on an old metal gate. From a distance it just looked rather dilapidated and past its best, but looked at through a macro lens it became another world, an abstract landscape of shape and color. I spent a long time looking for a patch with just the right balance of colors, avoiding any bare or rusty areas. The paint was on a fairly flat plane, so I made sure that my camera was parallel with it and depth of field was not a problem. Without anything to give a sense of scale, an abstract photograph like this gives free rein to your imagination.

Nikon D2x, 105mm macro lens, ISO 100, f/10 at 1/30 sec

The rule of thirds

There are various compositional "rules" that can help in finding a successful composition, and perhaps the best known of these is the Golden Rule, or the rule of thirds. This states that if you imagine a grid of two vertical lines and two horizontal lines across your photograph, and then place your subject either along one of these lines or on one of the points where they intersect, your picture will be visually more interesting than if you place your subject centrally within the frame. In many cases this will be true, as an off-center subject is often more dynamic visually than a central one, which can be rather static; but, like all rules, this one is meant to be broken on occasion! It's a good idea to bear it in mind as a guideline, and evaluate as you look through the camera whether or not your subject would look better if you followed the rule of thirds.

Tree and sand dunes, Sahara
In the low evening sunlight this vista of small sand dunes in the Sahara really did resemble waves in a sea. I felt that the view needed something to act as a focal point and anchor the image, so I used this tree, positioning it within the frame according to the rule of thirds.
Nikon D2x, 18–200mm lens at 200mm, ISO 100, f10 at 1/60 sec

Almond tree

This pretty little almond tree was growing on its own at the edge of a field, and there were various different ways to approach the composition of a photograph. I decided to crop in quite tightly, as the upper branches of the tree had less blossom on them. This left me with the question of whether to have the trunk of the tree central within the image or off to one side, and I felt that having it to one side made a more interesting photograph, especially since the tree itself was asymmetrical—if it had been a symmetrical tree I might have made a different choice. So in the resulting image the tree trunk lies approximately along one of the vertical one-third lines, and the soft golden grasses go up to the lower of the horizontal one-third lines, with the blossom filling the upper two thirds. The result is a balanced feel to the photograph, which is in keeping with the gentle nature of the subject.

Nikon F100, 28–105mm lens, Fuji Velvia 50

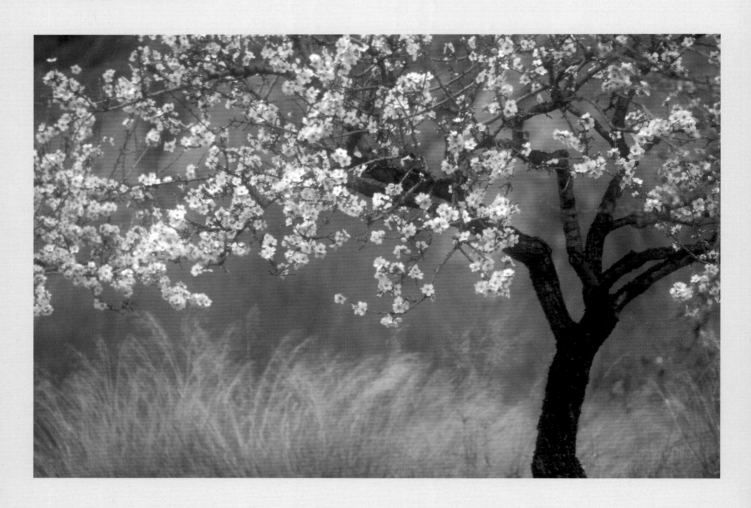

Tuscan sunrise

I seldom previsualize photographs, as I usually try to keep an open mind and remain receptive to whatever I see. On a particular trip to Tuscany, however, I had previsualized a misty dawn picture with perhaps a house appearing as the sun rose through the mist. Despite getting up for several sunrises, my hoped-for photograph did not materialize. On this particular morning, as I stood in the pre-dawn gray, I was surrounded by fog, and it seemed that it was too dense for anything to become visible. After a while, though, a silhouette of a house and cypress trees appeared, so I photographed it, even though there was no sun, positioning it in the lower left part of the frame; then the silhouette was swallowed up again by the fog. Ten minutes or so later, and in a different direction, the sun finally appeared through the mist, so I took another photograph of that, putting it in the top right third of the frame. Back at home, I sandwiched the two transparencies together and rephotographed them, finally achieving my previsualized image. Having the house and the sun on two of the golden rule intersection points has given a visual balance to the composition.

Nikon F3, 200mm lens, Fuji Velvia 50

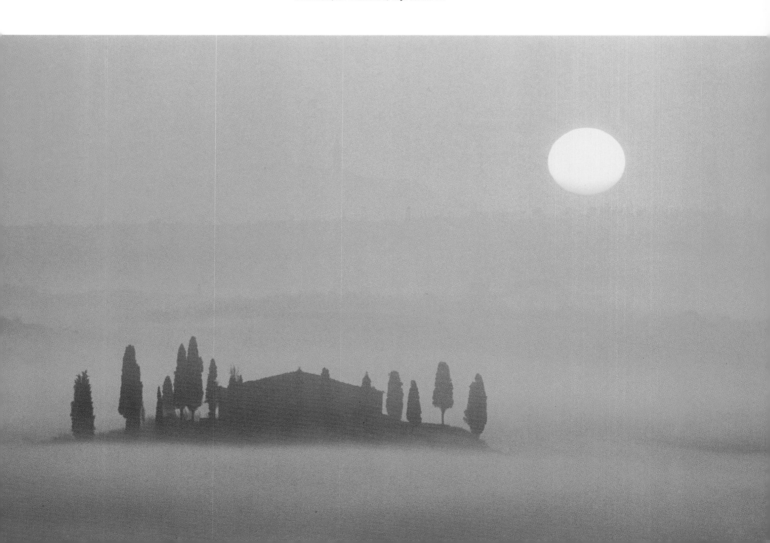

Keyhole

This old lock was part of the same gate whose flaking paint we saw on page 108, and I was intrigued by the way you could just glimpse some of the greenery on the other side of the gate through the keyhole. As the keyhole was surrounded by a fairly even distribution of interesting paint tones, I had a free choice of where to place it within the image. In the first of these photographs (above left), I positioned it fairly centrally; for the second (above right), I went in a little closer and positioned the keyhole on one of the rule of thirds intersection points. I think the second composition is more interesting and visually dynamic than the first, and has the added bonus that the green seen through the keyhole is balanced by the only patch of green paint among the oranges and pinks.

Nikon D2x, 105mm macro lens, ISO 100, f/10 at 1/80 sec (above left)
Nikon D2x, 105mm macro lens, ISO 100, f/8 at 1/125 sec (above right)

Where to put the horizon

In any landscape image that includes sky you will need to make a decision about where to put the horizon in your photograph. Very often the rule of thirds (see page 109) will apply here—a photograph where the horizon cuts straight across the middle of the image will often be less interesting visually than one where the horizon is on one of the one-third guidelines. But, of course, there are many other options for placing the horizon within the frame, and sometimes a more radical composition with the horizon either very low or very high will lead to a photograph with more impact.

The decision will largely rest on the amount of interesting "information" in the sky and in the land below it. If the sky is plain clear blue or just overcast, it will usually be better not to include too much of it, as it will not provide much visual interest in the composition. On the other hand, if you are lucky enough to have a dramatic stormy sky or some beautifully colored clouds at sunrise or sunset, you may want to devote the majority of your image to the sky, with the land below simply providing a base for it.

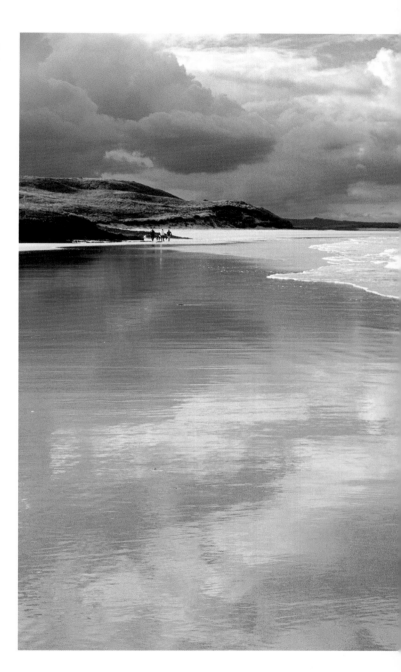

Beach in Northumberland, England
I felt that the interest in this scene lay in the reflections of the sky in the wet sand, so to emphasize these I used a wide-angle lens and placed the horizon two-thirds of the way up the frame, devoting most of the image to the beach. The wide-angle lens has also had the effect of pushing away the piece of headland, which is not very interesting in itself, allowing the photograph to be mostly about the stormy sky and its reflection.
Nikon F3, 28-105mm lens, Fuji Velvia 50

Blue landscape, Namibia

These blue sodalite rocks under the blue African sky provided
the ingredients for a rather surreal landscape. Although the main
attraction of the scene lay in the unusual colors of the rocks, the sky
also had interest because of the wispy white clouds. Nevertheless,
I felt that to have the horizon halfway up the picture would be too
static visually, so I gave two thirds of the frame to the rocks and
one third to the sky.

Nikon F3, 24mm lens, Fuji Velvia 50

Near Narsarsuaq, Greenland (right)

This bleak Arctic landscape consisted mainly of monochrome grays
with just hints of blue and very pale lemon. I chose to put the horizon
very low in the frame so that I could include the brooding dark clouds
that loomed above. I was pleased to be able to have the dark gray
at both top and bottom edges of the image, containing the lighter
tones within.

Nikon D2x, 18–200mm lens at 150mm, ISO 100, f/13 at 1/320 sec

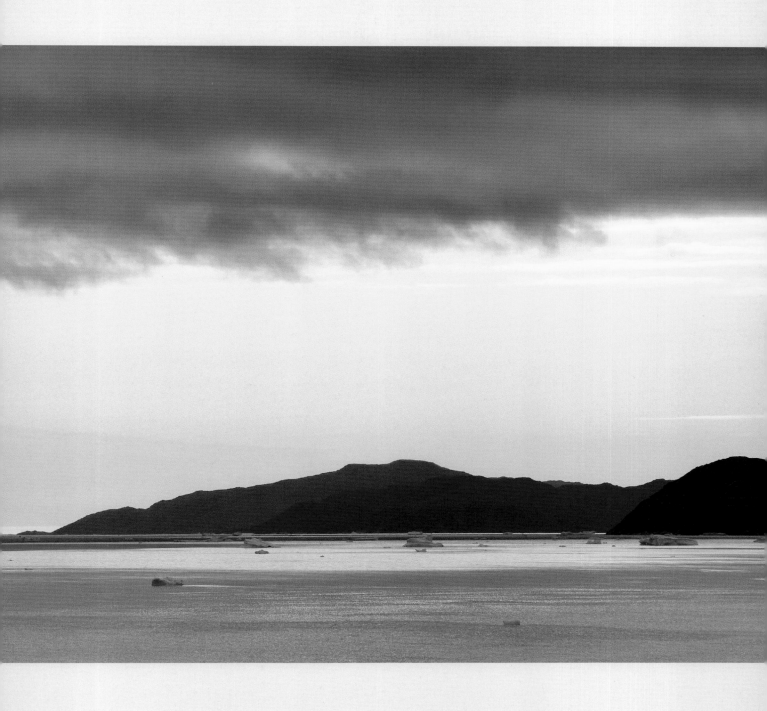

Sunset over the sea

It may be a cliché, but there can be few sights more breathtakingly magical than a beautiful sunset over the ocean. Since the sea on this occasion was not reflecting any of the light, I put the horizon very low in the frame so that the sea simply provided a base for the glorious colors in the sky.

Nikon D2x, 80–400mm lens at 80mm, ISO 100, f/6.3 at 1/250 sec

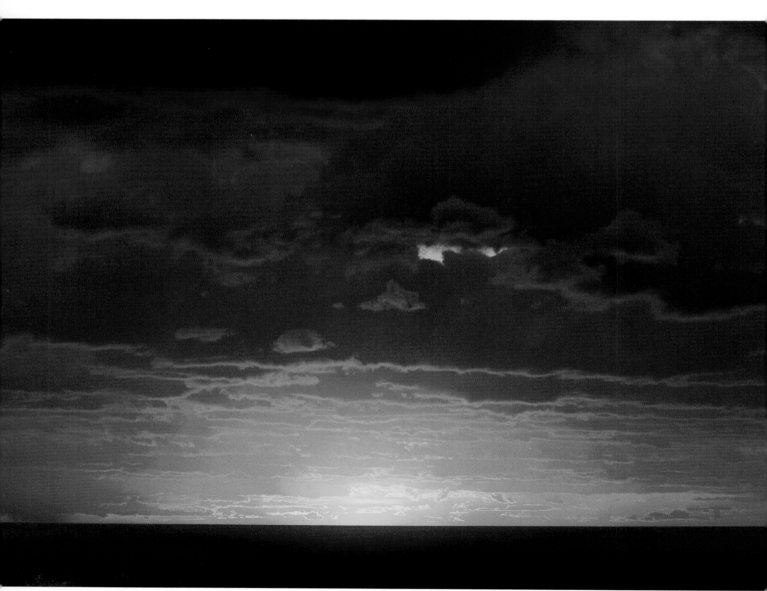

Symmetrical compositions

Although the elements within a scene frequently lend themselves well to the application of the rule of thirds, there will be times when a more symmetrical composition will be better suited to the subject. I mentioned when discussing the photograph of an almond tree on page 110 that one of the reasons I chose to use the rule of thirds was because the tree itself was asymmetrical; if the tree had been symmetrical I might have chosen instead to put the trunk centrally in the image. A symmetrical image may be less visually dynamic than an off-center composition, but it will often have a lovely sense of balance and calm.

Pink tulip
This pink tulip was perfect in itself, and I wanted to make a simple, straightforward photograph of it, so I decided to opt for a balanced composition with the flower's stalk central in the frame. Also, because I wanted to include the entire flower in the image and not crop into the petals, putting the stalk on one of the one-third lines would have meant including more background.
Nikon F3, 55mm macro lens, Fuji Velvia 50

Yellow house, Burano, Italy

Burano is a small island near Venice that consists of a few streets of brightly painted houses, but even among its vividly hued neighbors this particular house shone out. I felt that the composition had to be symmetrical–this was a situation in which the rule of thirds played no part! Having decided on symmetry, I tried to make the framing as precise as possible, so that the distance from each window to the edge of the frame would be the same. Incidentally, the plaque to the left of the door has a quotation in Italian followed by an English translation: "Color is like music, it uses shorter way to come to our senses, to awake our emotions."

Nikon D2x, 18-200mm lens at 105mm, ISO 100, f/14 at 1/40 sec

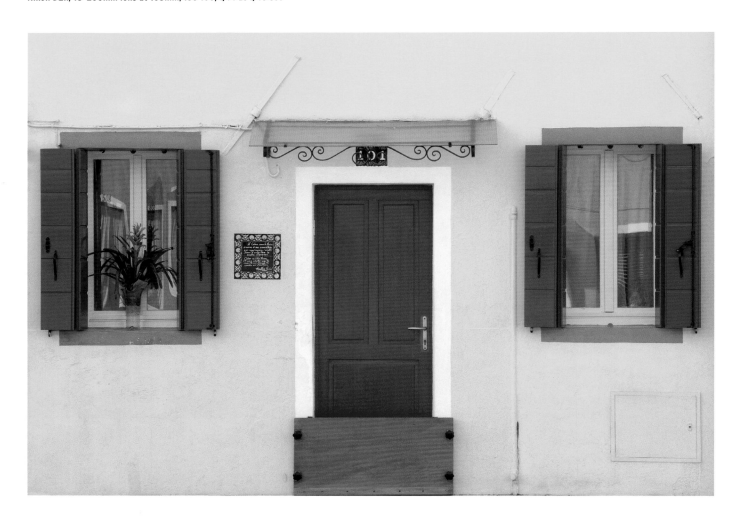

Pink osteospermum
Flower centers often lend themselves well to symmetrical compositions, especially flat, daisy-type flowers such as this osteospermum. Do take care that your chosen flower really is symmetrical in itself for this type of picture, as sometimes the petals will be slightly different sizes or shapes on each side, and if this is the case it might be better to make an asymmetrical composition instead.
Nikon D2x, 105mm macro lens, ISO 100, f36 at 1.6 sec

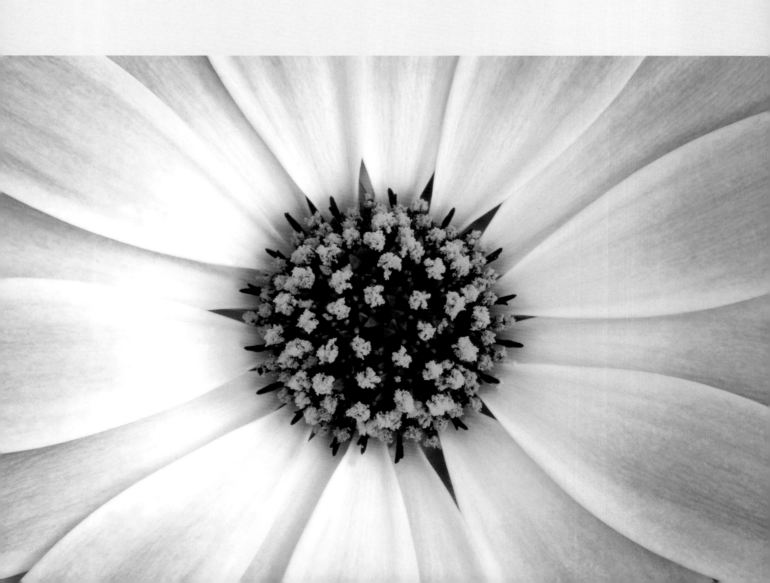

Achieving balance in a composition

There is no easy set of rules that can be followed to achieve a well-balanced composition, because every scene or subject is different and each one will have to be individually evaluated. Guidelines such as the rule of thirds, and ideas about lines within an image, the interaction of colors, and the effect of the light on the subject, help with the decision-making process; but in the end, the final judgment about the balance of the composition is largely intuitive. The best way to fine-tune your awareness of compositional considerations is by continually practicing—perhaps by taking photographs of the same subject in more than one way and then evaluating which one works best and why. It's also good to look at the work of other photographers and artists in other mediums and to try to assess why some compositions appeal to you while others may not.

There may be occasions when, after weighing up all the elements and colors in the scene, you decide that you just can't make a satisfying composition out of them. This is not a sign of failure, but of the fact that you have become more discerning in your judgment of what works and what doesn't in an image.

Tuscan landscape

At the end of an overcast day the sun broke through the clouds just before it set, and I had only a short time to compose a photograph from the elements in the landscape in front of me. Luckily for me the scene was so well balanced that it practically composed itself! The winding road leads the viewer's eye in from the bottom left of the frame and up toward the house, which I placed approximately on one of the golden rule one-third points. The eye then moves across to the single tree, which is also approximately on a one-third point and provides a lovely counterbalance to the house, before moving back down to the base of the road. This triangular, balanced composition is visually satisfying and helps to create a serene and restful feel to the photograph.
Nikon F100, 28-105mm lens, Fuji Velvia 50

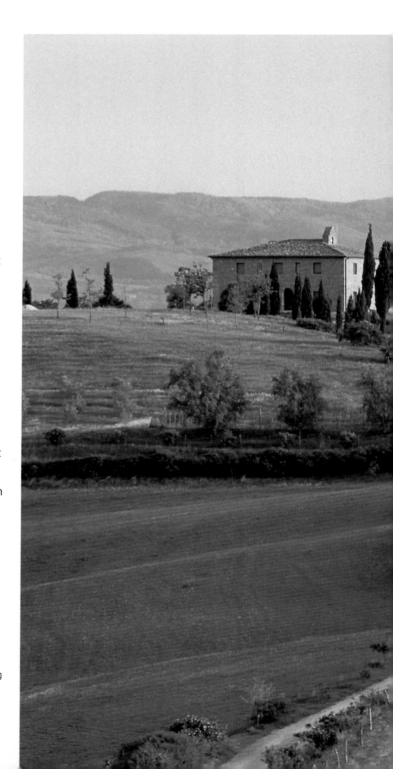

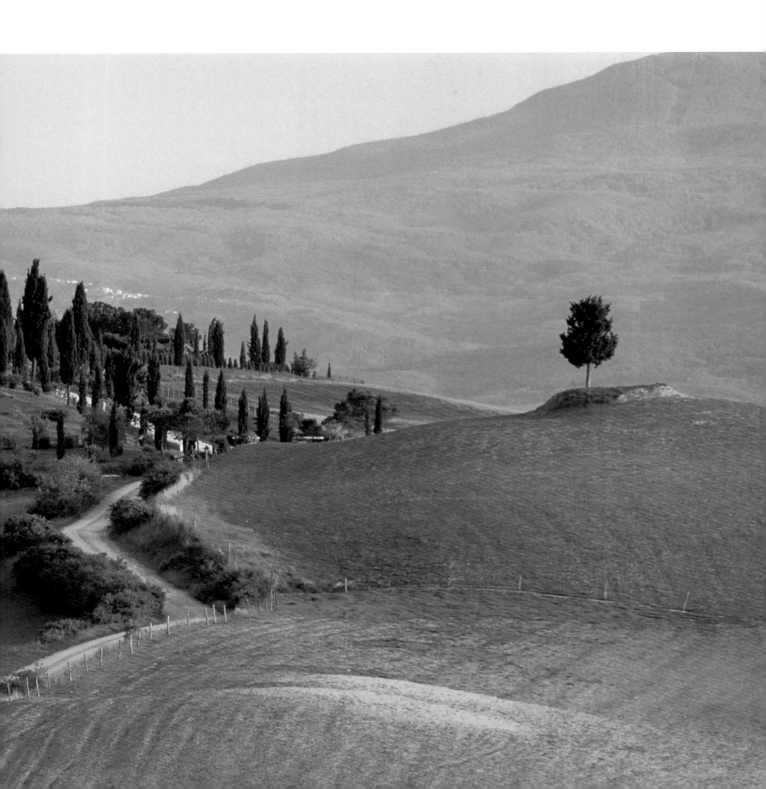

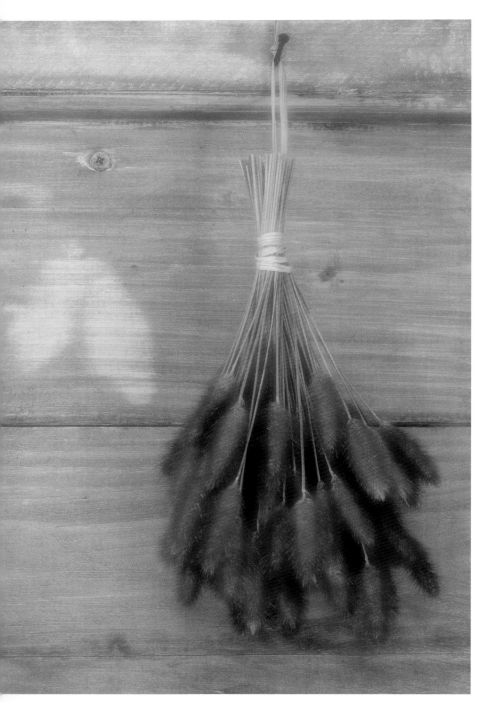

Dried grasses

Sometimes the balancing element in a composition can be very subtle—the viewer may not be consciously aware of it, but nevertheless it plays an important part in the overall balance of the image. In this photograph, the faded leaf-shaped patch of wood is surprisingly important. Had the wall been uniformly blue I could have placed the grasses either centrally, which would have been rather static, or on one of the rule of thirds lines, which would have left an area of blue background that was not adding a great deal to the image. As it was, I was able to place my bunch of grasses slightly off center, and the similarly shaped faded patch acts as a subtle counterbalance to the subject.

Nikon D2x, 28–70mm lens at 70mm, ISO 100, f/22 at 9 sec

Gateway, Venezuela (right)

On the day I took these photographs I had my compact camera but no tripod with me. When I saw the gorgeous colors of the gate and the wall outside I knew I wanted a picture, but had to wait for quite some time for a gap in the line of tourists going in and out before I could get a clear view. I liked the way the mirror on the left was reflecting the blue of the wall outside, so I decided to include that in the photograph too. I took the first of these pictures, but because I was handholding my camera, I wanted to have another go, so I waited again for the next lull. Just as my opportunity came, a lady walked into the gateway and looked out—I took one photograph, and then she turned and saw me and the moment was over. By pure serendipity, she has provided the perfect balance to the photograph, providing a focal point and also a counterpoint to the mirror.

Panasonic DMC-LX2, lens at 10.8mm, ISO 100, f/8 at 1/40 sec
(top right)
Panasonic DMC-LX2, lens at 11.6mm, ISO 100, f/8 at 1/30 sec
(bottom right)

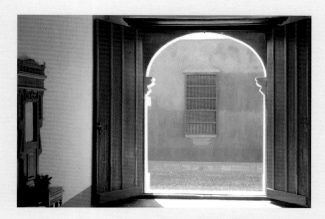

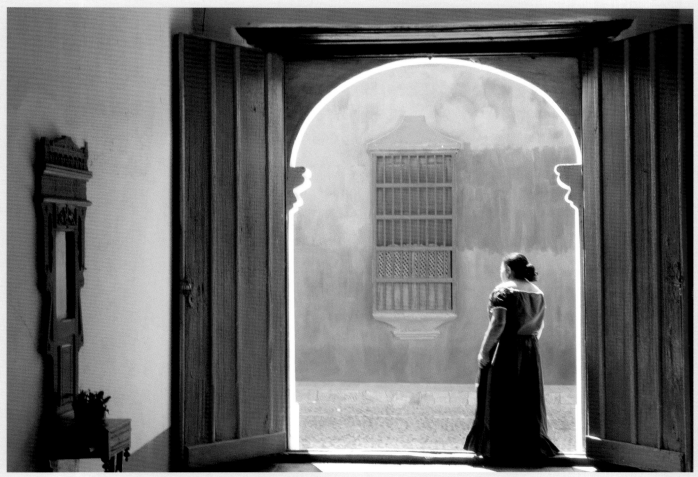

Orientation

One of the factors that need to be considered when arranging your composition is the orientation of the camera—that is, whether you take a vertical (portrait) or horizontal (landscape) photograph. Clearly this will make a fundamental difference to the resulting image, changing the balance of the photograph entirely. Very often the nature or shape of the subject will dictate which orientation will work best, but when this is not the case I usually look through the camera at both portrait and landscape formats and evaluate which one enables me to make the most satisfying composition. In addition to the overall shape of the subject, you may need to consider whether or not you wish to crop into its edges, what the background is like, and whether there are any elements nearby that you want to include or exclude from the frame.

Poplars and wild garlic
My first instinct on seeing this lovely stand of poplars was to frame the picture in a portrait format because of the fact that the trees are tall, thin, and vertical. However, when I compared the landscape orientation I liked it much better, because it gave more of a sense of depth and of the scale of the plantation; also, there is not much interesting information in the upper half of the portrait-format picture.
Nikon F100, 28-105mm lens, Fuji Velvia 50

Spider's web with frost

This spider's web looked magical with frost sparkling on every strand, but I had to compose quite tightly as the web was not complete and the area to the left of the part shown here was broken. Because of this I knew I would need to put the center of the web on the left side of the frame, but I still had a choice of vertical or horizontal orientation for the photograph. I think that in this case the vertical picture works best, as it makes the most use of the more interesting and complete parts of the web.

Nikon D1x, 105mm macro lens, ISO 125, f/18 at 1/25 sec (top)
Nikon D1x, 105mm macro lens, ISO 125, f/20 at 1/15 sec (bottom)

Lines within the image

Within the frame of your photograph there may be lines, such as a road, a row of trees, or the line of the horizon. The placement and angle of such lines will affect the dynamism of your image. As we have already seen when considering where to put the horizon, a horizontal or vertical line placed centrally within the frame of the picture will be more static than one placed off center. Horizontal or vertical lines are also thought to be more static and less interesting visually than diagonal lines, which are more dynamic.

Cotswold cottages, England

This little line of cottages with a lush meadow in front of them looks quintessentially English. The first picture (far left) shows the view that I saw first, but two things bothered me about it: first, the meadow grass hid the whole of the lower storey of the cottages so that none of the doorways were visible; and second, the cottages formed an almost horizontal line approximately halfway up the frame, which made for rather a dull and static composition. By walking a bit to my left and climbing up onto a wall I was able to get a better viewpoint (below), revealing at least some of the lower storey of the cottages. Also, because I was now at an angle to the cottages instead of facing them flat on, their line is leading away from me in a more interesting way than the static straight line in the first image.

Nikon D2x, 28–70mm lens at 38mm, ISO 100, f/22 at 1/8 sec (left)
Nikon D2x, 28–70mm lens at 62mm, ISO 100, f/16 at 1/20 sec (below)

Lichen and leaves on rock
Because there was nothing in this image to give an indication of what was the "right way up," I could choose where to place the line of green leaves within the frame. I decided to have the line leading from the top left corner of the frame to the bottom right, creating a diagonal line. I think this makes the image more interesting visually than it would have been if the line of leaves had gone horizontally across the frame.
Nikon F3, 55mm macro lens, Fuji Velvia 50

Flowers on dry stone wall
The diagonal lines in this dry stone wall made for quite a dynamic composition. To create a focal point in the image I positioned the larger of the clumps of flowers on one of the rule of thirds points, using the smaller clump as a counterbalance.
Nikon F3, 55mm macro lens, Fuji Velvia 50

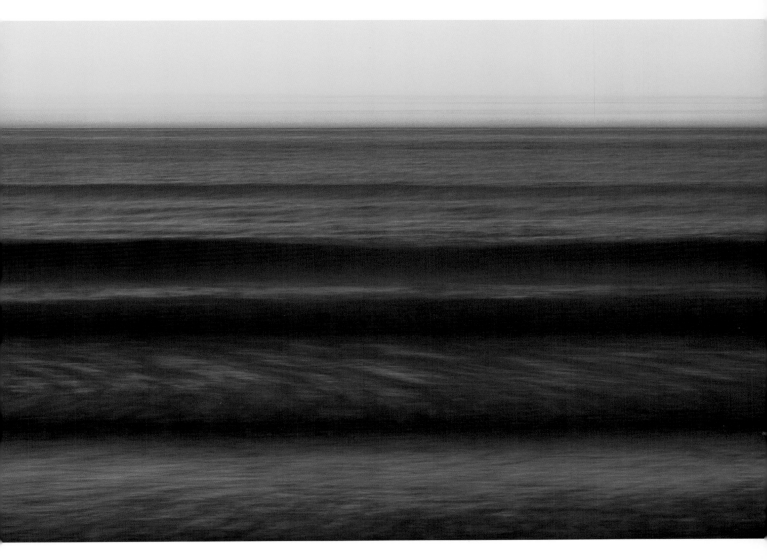

Abstract sea

To make this abstract image of the sea just after the sun had set, I put my camera on a tripod and used a long exposure to blur the movement of the waves. The repetition of horizontal lines within the image is visually restful and creates a serene feel.

Nikon F3, 200mm lens, Fuji Velvia 50

Leading the eye into the picture

A lovely compositional technique is to organize the arrangement of the elements in the scene you are photographing in such a way that one of them leads the viewer's eye into the image. This will more often be a possibility with a landscape photograph—where you can make use of a path, road, or river—than with a close up.

In the picture of the Tuscan landscape on page 120, I mentioned how the winding road led the eye into the image and up to the main subject, the house. Conversely, if you have an object in the foreground of an image that is acting as a barrier, such as a wall or fence, it can have the effect of shutting the viewer out of the landscape beyond.

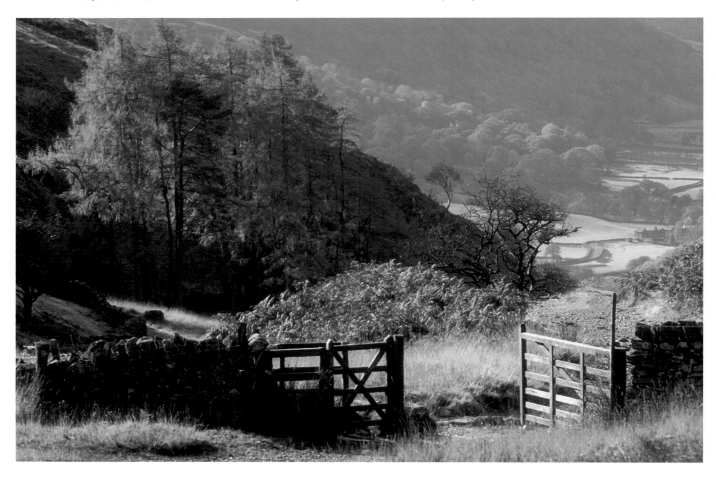

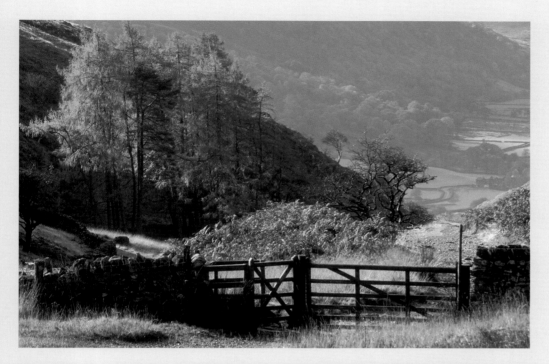

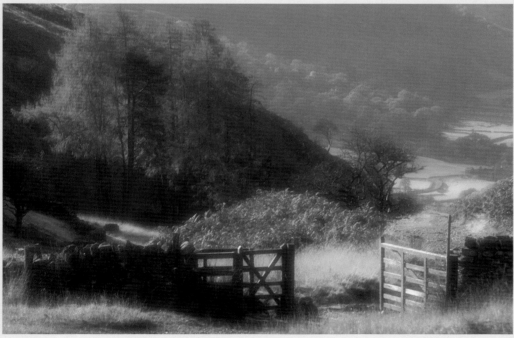

Lake District gate, England

I loved the colors of the grass and the gentle lighting in this Lake District scene. However, I felt slightly dissatisfied with my first picture (top left), and it took me a little while to work out why. When I realized, I opened the gate and took the second picture (far left). This has greatly improved the composition; instead of the closed gate shutting the viewer out, the open gate invites the viewer through and into the landscape beyond. For the third photograph (bottom left) I added warm-up and soft-focus filters. I hasten to add that I shut the gate again afterward!

Nikon F100, 28–105mm lens, Fuji Velvia 50

Tuscan avenue

I photographed this lovely avenue of cypress trees at a time
of day when the light was coming directly from the side, casting
the shadows of the trees horizontally across the road. The avenue
leads in a gentle diagonal off toward the top right of the frame
and invites the viewer into the picture. I made sure that I had
a stripe of shadow rather than a stripe of sunlight at the bottom
of the photograph, as this helps to hold the image within its frame.

Nikon F100, 28-105mm lens, Fuji Velvia 50

Peony (right)

I decided to fill the frame with this beautiful peony in order to
exclude the leaves and stems around it and concentrate the
viewer's attention on the lovely colors and curves within
the flower. I didn't want to crop into the edges of the petals,
so I left just enough out of focus green around the peony to
give it breathing space within the frame.

Nikon D2x, 105mm macro lens, ISO 100, f/11 at 1/50 sec

Making the subject large or small within the frame

As photographers we have a great deal of control over the size of our subject within our frame, especially with the flexibility of zoom lenses giving us a wide range of focal lengths to choose from. Once we have seen a flower or a tree or a building that we like, we have to decide whether to zoom in and completely fill the frame with it or whether to include its background or environment within the image. Simplicity in a composition will usually lead to a stronger photograph, and often this will mean going in closer—but this will not always be the case, and each situation needs to be carefully evaluated.

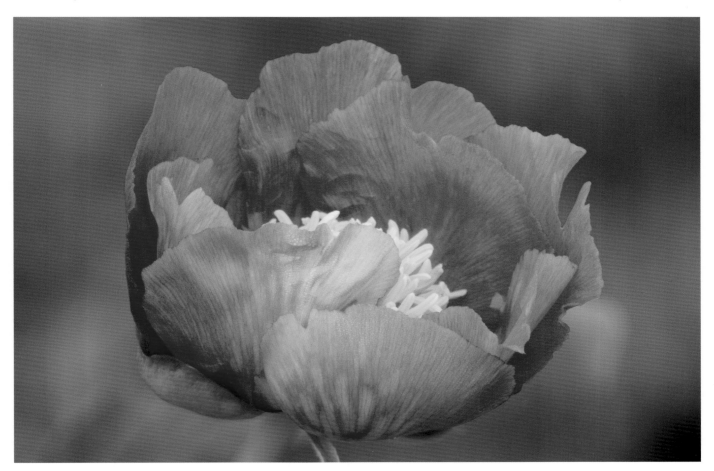

FILLING THE FRAME WITH YOUR SUBJECT

If the area around your subject is not particularly interesting or informative, it will usually be better to exclude it. If, for instance, you are photographing a flower, it will often be better to fill the frame with the bloom itself and exclude the surrounding leaves, stems, and twigs. Or perhaps you have been attracted by a picturesque old building in Italy—but is the whole building attractive, or is your eye really being drawn by a window with gorgeous faded paint on its shutters? If the rest of the house is not very interesting, it will be much better to zoom in on the window and exclude the rest. In any situation, ask yourself what it is that attracts you to take the photograph and concentrate on that, excluding anything that is unappealing or that is simply not adding to the image.

French windows

I was immediately drawn to this building in a little village in France because of the wonderful shade of blue paint on its walls. However, I felt that a view of the whole building (below) was too cluttered to be successful—it's difficult for the eye to know where to rest in the image. In addition, various elements within the picture were less attractive, such as the concrete wall on the upper storey of the building and the rather tatty aloe plants on the left. In the end I decided to zoom in and make just one of the windows the subject of the photograph, and this has created a much simpler and more pleasing composition (right).

Nikon D1x, 28–105mm lens at 28mm, ISO 125, f/18 at 1/30 sec (below)
Nikon D1x, 28–105mm lens at 56mm, ISO 125, f/18 at 1/30 sec (right)

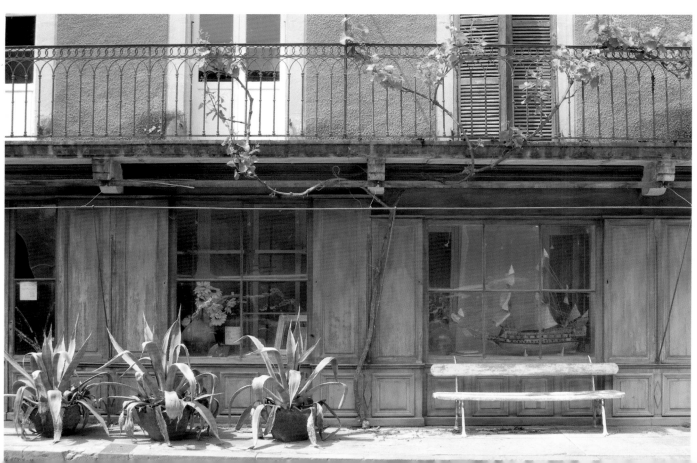

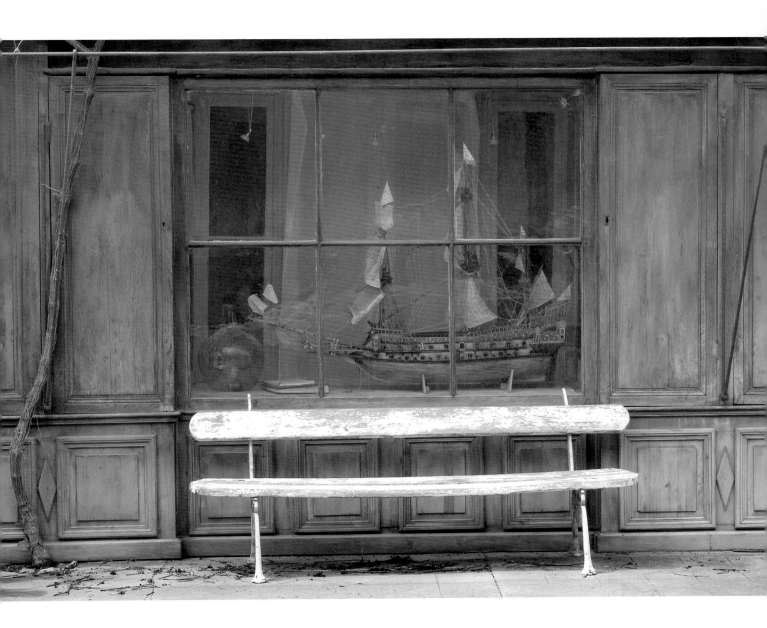

ALLOWING SPACE AROUND YOUR SUBJECT

Very often the key to a photograph with maximum impact is to move in as close as possible to the subject, filling the frame with it and excluding everything else around it. However, there are also occasions when the opposite is true, and it can be better to pull back a bit and have the subject smaller in the frame. This can be because the background to the subject or its environment is interesting or attractive or adds something important to the image; perhaps, for example, an image of a geranium growing in a terracotta pot in France will be enhanced if the wall behind it, with its lovely texture and faded shades of paint, is also included in the frame. Or a photograph of a lone tree in a vast prairie may be more effective if the tree is small within the image, allowing the viewer to sense its insignificance and isolation in the wild landscape. Or maybe sometimes you will simply sense intuitively that your subject needs more breathing space around it.

Church near Krysuvik, Iceland

I have only spent one day in Iceland, and I went on a coach trip to visit some of the country's highlights. As the coach arrived at this little church in the middle of nowhere, I was excited to see a wonderful dramatic sky behind it. I was less happy to realize that I was at the back of the coach and that all the passengers were going to get off the coach and file up to the church to go inside—I'm usually quite good about allowing other people to go first, but on this occasion I was off the bus almost before it had stopped! I had only a minute before people got into the picture, so no time even to set up a tripod. My instinct was to leave the church fairly small within the frame, to show how isolated it was in its environment, and also to make the most of the gorgeous sky. Putting the church on one of the one-thirds points strengthened the composition.

Nikon D2x, 18-200mm lens at 36mm, ISO 100, f/10 at 1/125 sec

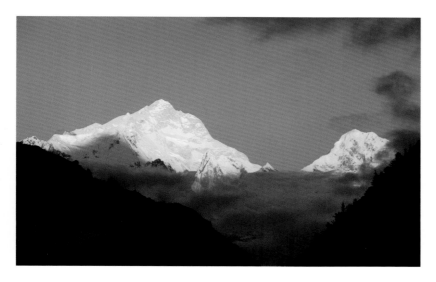

Manaslu at sunset, Nepal

At the end of a long day's trekking in the Himalayas, I was overwhelmed by the beauty of the peak of Manaslu gilded by the setting sun. Instead of zooming in on the peak alone I decided to take a wider picture, including some silhouetted trees and the rather atmospheric clouds—and as I composed my image the clouds parted for a fleeting moment to reveal the almost full moon (below). When the moon disappeared again I used a longer focal length on my zoom lens, making the peak larger within the frame (left). In the end the wider view was my favorite image from the evening, as I felt that the moon and clouds added an ethereal atmosphere to the drama of the mountain peak. Note how the light on the peak is more golden in the second photograph because of the warmer color temperature of the light as the sun went down (see page 82).

Nikon D2x, 18-200mm lens at 52mm, ISO 100, f/9 at 1/60 sec (below)
Nikon D2x, 18-200mm lens at 120mm, ISO 100, f/9 at 1/80 sec (left)

Using depth of field

Although your choice of aperture will not affect your composition in terms of the arrangement and balance of the elements within it, it can nevertheless influence the overall effect of your photograph quite dramatically. Also, assuming you choose a wider aperture so that only part of your photograph will be sharply focused, you need to make a decision about where your point of sharp focus will be. This is particularly critical in close-up photography.

The decision will largely depend on what you are trying to convey in your image. If you are photographing a sweeping vista, the chances are you will want front-to-back sharpness, and so will select a small aperture; but if you want to draw attention particularly to one element in your composition, one way to do this is by differential focus—in other words, using a wide aperture and focusing on the element you want to be sharp, allowing the rest of the picture to be softly defocused.

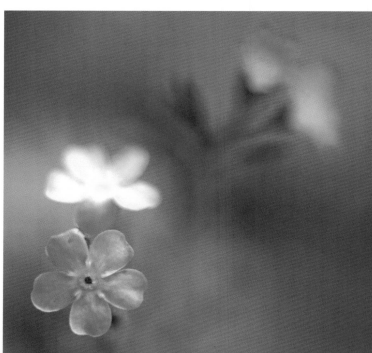

Forget-me-nots and buttercups
A photograph of these flowers taken from my standing eye level with my macro lens was completely uninteresting (top right). However, when I lay flat on the ground and used my lens's closest focusing distance and widest aperture, I became immersed in a whole new world. As I made slight changes to my position, different flowers came in and out of focus, and I enjoyed using a very shallow depth of field and allowing large areas of the image to become defocused, creating soft washes of color.
Nikon F3, 55mm macro lens, Fuji Velvia 50

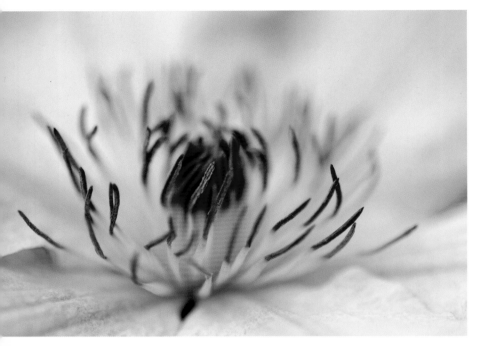

Clematis

At very close focusing distances, depth of field is extremely limited. The first of these photographs (top left) was taken at an aperture of f/3.8, and you can see that only a very small amount of the image is in sharp focus. The second photograph (bottom left) was taken at f/43, the smallest aperture on my lens, and the zone of sharp focus is much greater, but even so the picture is not completely sharp from front to back.

Nikon D2x, 105mm macro lens, ISO 100, f/3.8 at 1/400 sec (top left)

Nikon D2x, 105mm macro lens, ISO 100, f/43 at 1/4 sec (bottom left)

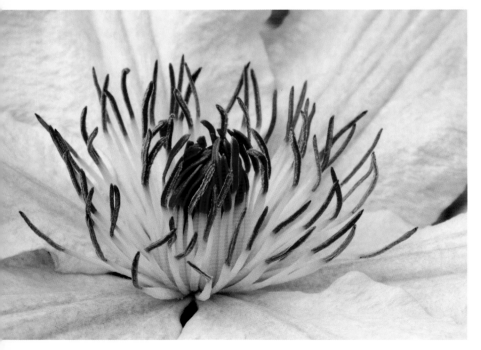

Orange trees and flowers (right)

For the first three of these photographs I used a wide aperture of f/3.5 and just changed my point of focus for each image—I focused on the foreground flowers in the first picture, about a third of the way into the scene in the second picture, and toward the back of the scene in the third picture. You can see how the choice of point of focus dramatically affects the resulting photograph. I then took a further photograph at f/22, focusing about one-third of the way into the picture, and this has given as much front to back sharpness as I could hope to get, given that I was standing quite close to the foreground flowers and tree.

Nikon D2x, 28-70mm lens at 70mm, ISO 100, f/3.5 at 1/250 sec (top left, top right, and bottom left)

Nikon D2x, 28-70mm lens at 70mm, ISO 100, f/22 at 1/6 sec (bottom right)

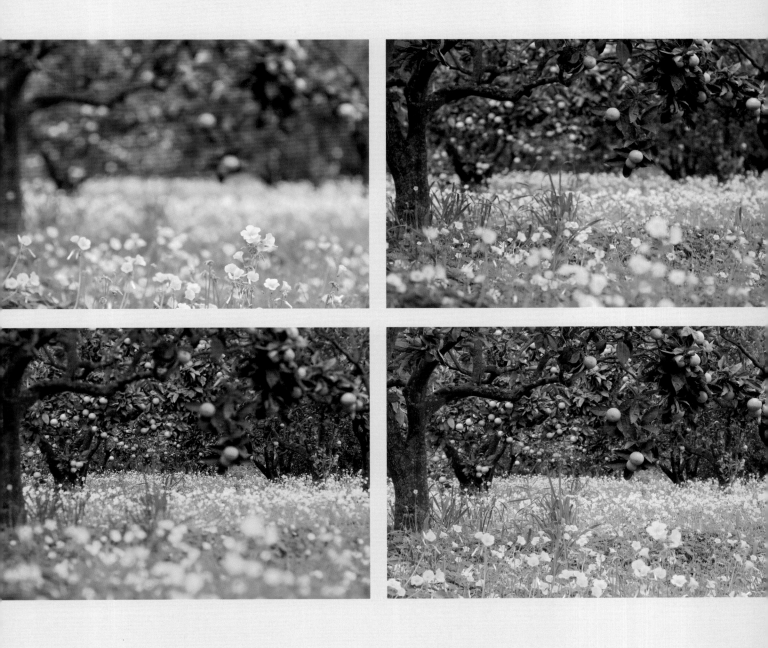

Simplicity

Very often the most successful compositions are simple.
If there are several different elements or colors within a photograph they may compete with each other for the viewer's attention; if this is the case you may need to make decisions about which of the elements you include, and try to exclude the others either by a change of framing or by a change of lens.

Dead Vlei, Namibia (right)
This surreal landscape lent itself very well to a simple, uncluttered composition. There are very few colors within the scene, and the two distant, smaller trees support the main subject tree without competing with it.
Hasselblad 500C, 80mm lens, Fuji Velvia 50

Cypress trees, Tuscany
This is a very simple landscape with only three elements—sky, trees, and grass. Because it is so uncluttered it has a calm, restful feel to it.
Bronica ETRSi, 150mm lens, Fuji Velvia 50

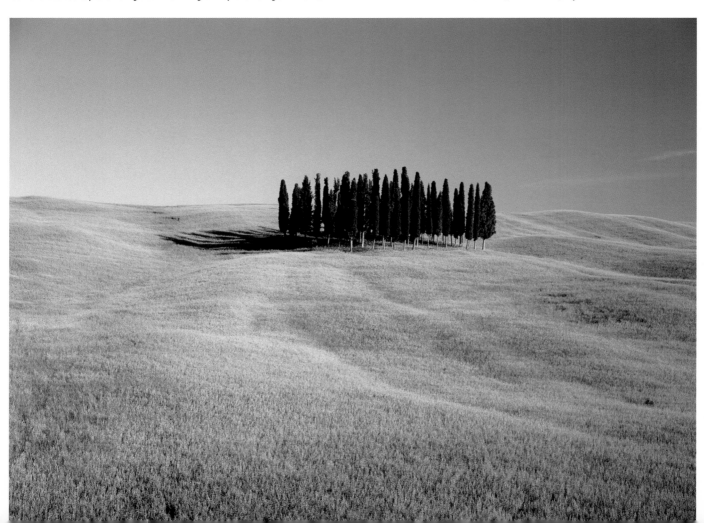

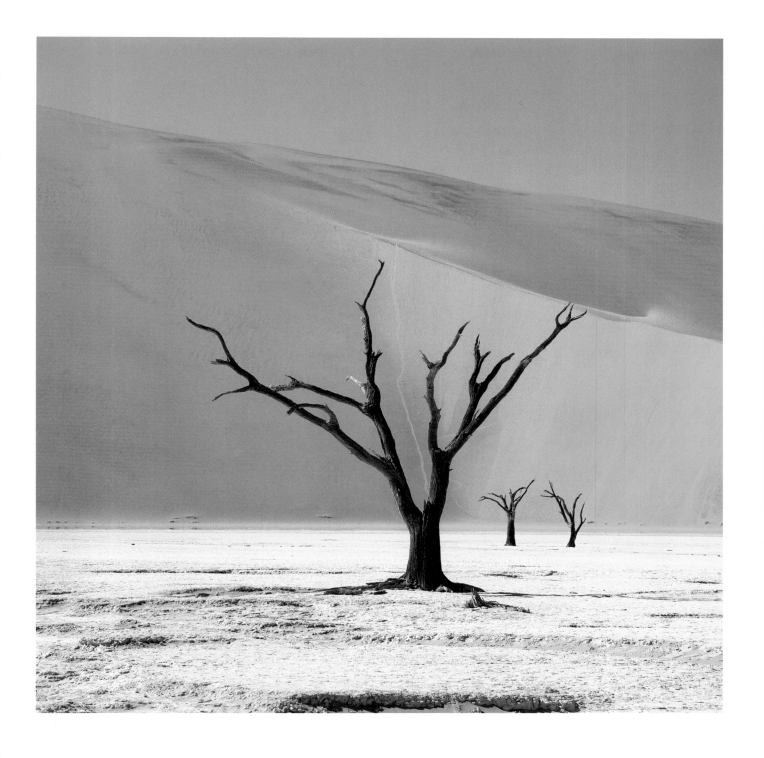

One effective way of simplifying a composition is to use a telephoto or macro lens to pick out elements from a scene or subject to create an abstract image. By doing this you can eliminate all unwanted clutter and focus only on the part of the scene that appeals to you because of its shape or color.

As a general rule, it is easier to make an abstract picture of smaller subjects—for example, a close-up of a leaf is more likely to provide an abstract image than a photograph of a whole tree. Occasionally, however, a wider view can provide an abstract image if the scene is very simple and there is no information to provide a clue as to the scale or size of the subject.

Cornish boathouse, England

During a walk on the Cornish coast I was delighted to come across this unusually colored boathouse. However, an overall view was very difficult, as there were many things in the scene that were not attractive, so I decided to exclude these by going in close with my macro lens and photographing just parts of the boathouse. First I photographed the stone that was hanging on the door, enjoying the contrast between the textures of the stone and the painted wood. When I was close to the door, I noticed that in places the pink paint was peeling away to reveal blue underneath, providing a wonderful source of images that were no longer about the boathouse itself, but were just about enjoying the colors and textures.

Nikon D1x, 28–105mm lens at 28mm, ISO 125, f/22 at 1/20 sec (top left)
Nikon D1x, 105mm macro lens, ISO 125, f/34 at 1/5 sec (bottom left)
Nikon D1x, 105mm macro lens, ISO 125, f/51 at 1/2.5 sec (right)

Lake reflections

Standing at the back of a catamaran on a lake, I noticed the way the white clouds and blue sky made a constantly changing pattern of reflections in the wake of the boat. I used a telephoto lens to exclude everything else and make an abstract image of the patterns in the water.

Nikon D1x, 80–400mm lens at 220mm, ISO 125, f/11 at 1/320 sec

White sand dunes, South Africa
As the setting sun touched these white sand dunes it tinted them pink, and the areas that fell into shadow took on a blue tone. Because there is little in the photograph to give a clue as to the scale of the subject, I was able to make a fairly abstract image consisting of gentle curves and colors.
Nikon F3, 28-105mm lens, Fuji Velvia 50

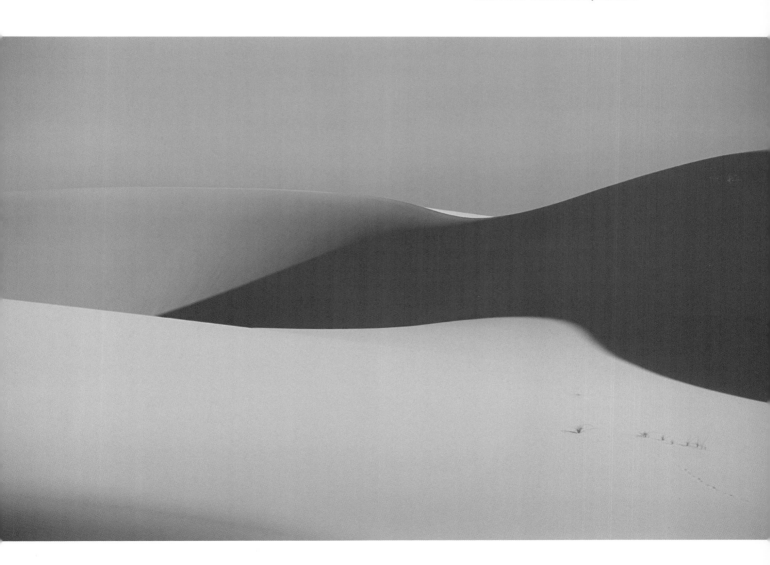

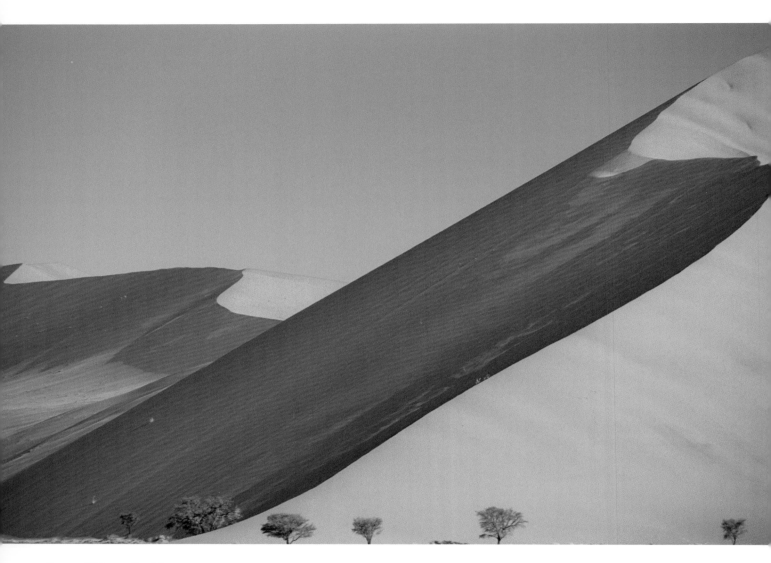

Dunes with trees, Namibia

Without the trees this image would be quite abstract in the
same way as the white sand dunes; but although they are tiny
in the picture, the trees are enough to take the photograph
away from the abstract because they provide a sense of scale
and a context of reality.

Nikon F3, 28-105mm lens, Fuji Velvia 50

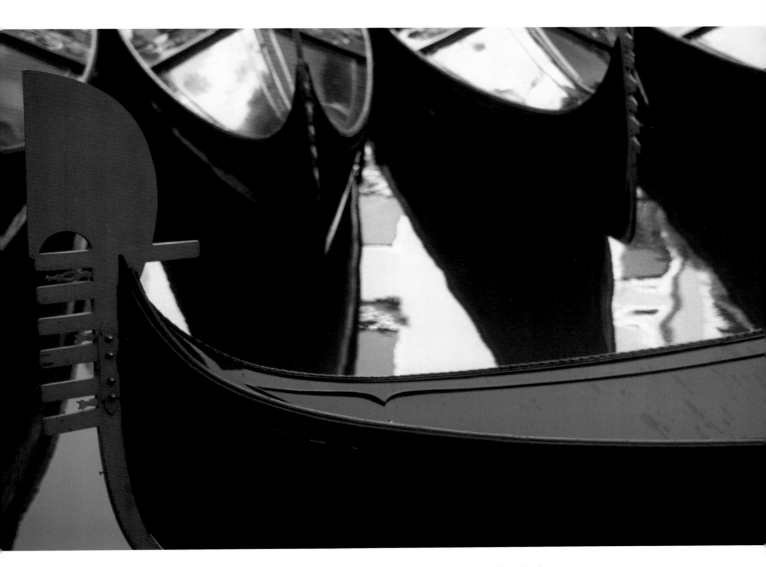

Gondolas, Venice
Several gondolas were moored together in water that was
reflecting the brightly colored wall of a nearby building.
With a telephoto lens it was possible to pick out many
different abstract compositions using just parts of the
gondolas with areas of reflected color between them.
Nikon F100, 200mm lens, Fuji Velvia 50

PANNING

Panning is a fun technique that can effectively simplify a scene by gently spreading the colors and removing detail. It involves moving the camera while the shutter is open, and this can either be done by moving the camera on a tripod head or by handholding. Generally I find that a shutter speed of around 1/8 to 1/15 sec works best, and the movement can be done in any direction. My favorite subject for this technique is trees, and for these I pan vertically from the bottom to the top.

Silver birches (right)

The first of these images (top right) shows the straight version of this scene. To make the second image (bottom right), I moved the camera vertically while the shutter was open, creating a simpler and more impressionistic image.

Nikon F100, 28-105mm lens, Fuji Velvia 50

Trees and bleached grass

I was attracted by the greens of these mossy tree trunks and the pale, bleached grass, but there were a lot of broken branches and twigs that would have looked rather messy in a straight photograph. The panning technique enabled me to simplify the scene, removing the untidy detail while retaining the basic shapes and enhancing the beautiful colors.

Nikon D1x, 80-400mm lens at 165mm, ISO 125, f/36 at 1/13 sec

Cropping pictures in Photoshop

Unless we are photographing under rigidly controlled studio conditions, it is unlikely that every photograph we take will fit neatly into the format provided by the camera. A photographer using an SLR that gives a rectangular image with proportions of 3:2 may sometimes wish for a squarer format, or even a panoramic "letterbox." This may be either because the balance of the composition within the rectangle feels wrong or because it is impossible to include the whole of the subject without also including an unwanted element in the frame. Luckily, this is a situation that can be easily remedied in Photoshop using the Crop tool.

A crop may sometimes be a tiny sliver removed from one edge or a more dramatic removal of a large part of the original image. Remember, though, when you crop off part of the image you are also reducing the pixel count and therefore the file size of your photograph.

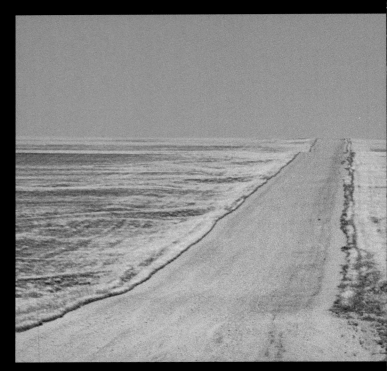

Namibian road

I chose a wide-angle lens to take this photograph because I wanted to exaggerate the perspective and emphasize the way that the road and fence lead the eye toward a distant horizon. However, wide-angle lenses do include a large amount of foreground, and this can be dull if there is not enough "information" in it. In this picture (right), I felt that the lower section of the image added nothing of interest—but raising the camera to exclude that part of the foreground would simply have included more sky, which would be equally uninteresting. The answer was to crop the picture in Photoshop. My first crop (top) was quite drastic and created a letterbox image, but I felt that this diminished the feeling of depth too much, and in the end I settled for the compromise of a less radical crop (far right).

Nikon F3, 24mm lens, Fuji Velvia 50

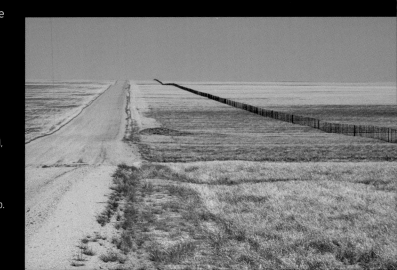

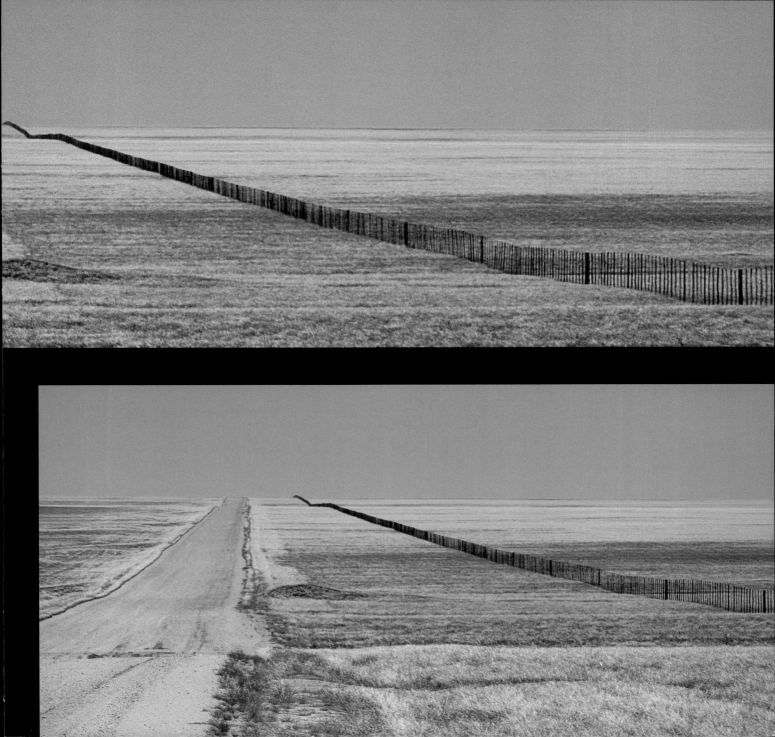

Door and pot

There was a lot of symmetry in this scene, so I decided to position myself carefully so that the pot was centrally positioned within the frame of the door behind it (top right). However, I then noticed that in fact the symmetry was upset by the inclusion of part of a window frame on the left and part of a tree on the right. It wasn't possible to zoom in and exclude these without cropping off the top of the doorway's arch, which I didn't want to do. The answer was to crop off the edges of the picture in Photoshop (above).

Nikon D2x, 80-400mm lens at 135mm, ISO 100, f/10 at 1/30 sec

1) Select the Crop tool in Photoshop or Photoshop Elements and drag it across the image—being right-handed, I usually find it easiest to start at the top left corner of the picture. In this case, I started by selecting the entire image with the Crop tool.

2) Using the square "handles," drag the edges of the image inward until they are at the place where you would like to make your crop.

3) When you release the mouse, the areas to be cropped off will appear shaded. When you are happy with your crop, press Enter (Return).

Glossary

Angle of view
The area of a scene that a lens takes in, measured in degrees.

Aperture
The opening in a camera lens through which light passes to expose the film or sensor. The relative size of the aperture is denoted by f/stops.

Autofocus (AF)
A through-the-lens focusing system allowing accurate focus without the user manually turning the focusing ring on the lens.

Bracketing
Taking a series of identical pictures, changing only the exposure, usually in half- or one-stop (+/-) increments.

Cable release
A device used to trigger the shutter of a tripod-mounted camera at a distance to avoid camera shake.

Color temperature
The color of a light source expressed in degrees Kelvin (K).

Color wheel
A diagram representing the relationships between the different colors.

Contrast
The exposure range between the highlight and shadow areas of an image.

Depth of field
The amount of an image that appears sharp. This is controlled by the aperture: the smaller the aperture, the greater the depth of field.

Diffuser
White material stretched over a frame that diffuses the light falling onto an object.

Exposure
The amount of light allowed to hit the film or sensor, controlled by aperture and shutter speed.

Exposure compensation
Intentionally giving more or less exposure than that suggested by the camera's TTL meter.

Filter
A piece of colored or coated glass or plastic placed in front of the lens.

Flare
Degradation of an image caused by light falling onto the lens.

f-stop
Number assigned to a particular lens aperture. Wide apertures are denoted by small numbers such as f/2, and small apertures by large numbers such as f/22.

Focal length
The distance, usually in millimeters, from the optical center point of a lens element to its focal point.

Histogram
A graph used to represent the distribution of tones in an image.

ISO (International Standards Organization)
A numerical scale representing the sensitivity of the film or sensor to light.

Macro lens
A lens that enables life-size or larger reproduction of the object photographed on film or sensor.

Manual focus
Choosing the point of focus by turning the focusing ring on the lens.

Panning
Moving the camera while the shutter is open to create an image with movement blur.

Reflector
A piece of white, silver, or gold card or material used to reflect light back into the shadowed side of an object.

Rule of thirds
A compositional device that places the key elements of a picture at points along imagined lines that divide the frame into thirds.

Shutter
The mechanism that controls the amount of light reaching the sensor by opening and closing when the shutter release is activated.

Telephoto lens
A lens with a long focal length and a narrow angle of view.

TTL (through the lens) metering
A metering system built into the camera that measures light passing through the lens at the time of shooting.

White balance
A range of settings on a digital camera that allows photographs to be taken without a color cast in any given lighting situation.

Wide-angle lens
A lens with a short focal length.

Index

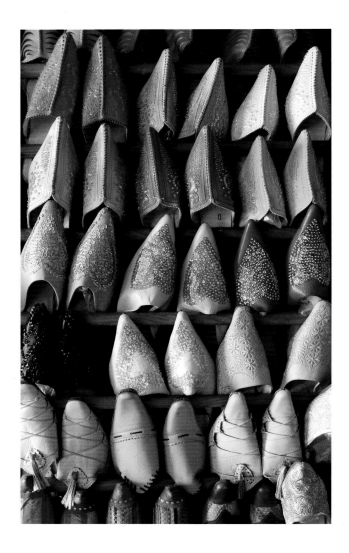

Photographers' Institute Press
Castle Place, 166 High Street, Lewes
East Sussex, BN7 1XU, United Kingdom

Tel: 01273 488005 Fax: 01273 402866
Website: www.pipress.com

Contact us for a complete catalogue, or visit our website.
Orders by credit card are accepted.